THE
SALT ROUTES

THE
SALT ROUTES

ANTHONY POULTON-SMITH

AMBERLEY

First published 2010

Amberley Publishing Plc
Cirencester Road, Chalford,
Stroud, Gloucestershire, GL6 8PE

www.amberley-books.com

British Library Cataloguing in Publication Data.
A catalogue record for this book is available from the British Library.

ISBN 978 1 84868 476 8

Typesetting by Amberley Publishing.
Printed in Great Britain.

CONTENTS

1

INTRODUCTION

Early routes were not trade routes. As is still seen in parts of the Third World, traditional paths are followed over the seasons. The elders have learned, from their forefathers and by experience, how to maximise the land and its resources to provide all their community could need.

Fresh water can be stored and channelled for drinking, washing, and irrigation. Edible plants provide green leaves, stems, tubers, and seeds which can be eaten or planted to grow crops. Meat can be hunted, trapped or taken from the fields of livestock.

However, there is one vital food item which cannot be grown or nurtured, a natural product which exists in vast quantities in few places and is often difficult to extract. Animals also require salt in their diet, predators get it from their prey, the prey get it from salt licks and the huge herds of the African plains wear paths in the landscape as they make regular trips over many miles to find the salt lick. It is easy to see how man, with his superior brain, learned that by following the beasts and/or the tracks the salt source would be revealed to them. In the earliest days of farming, mankind had a greater proportion of vegetable matter in their diet and, as hunter gatherers, meat would have formed an even smaller percentage – indeed, they should probably be known as gatherer hunters. Eventually, as they had done by domesticating livestock and nurturing their own cropfields, they procured their own salt.

In the history of man, science largely agrees on the so-called 'Out of Africa' theory, where humanity is thought to have evolved in and around East Africa's Great Rift Valley. In particular is the largely untouched Olduvai Gorge, christened the Cradle of Mankind, and an archaeological dream find in 1911. Among the bones, tools, and other evidence are a series of pits which have been shown to be artificial; they are not natural features. Over a small area are pits of varying sizes, between three feet and six inches in diameter and from two feet to six inches in depth. Digging pits for storage is common to every culture known throughout history; however, in the case of Olduvai Gorge it

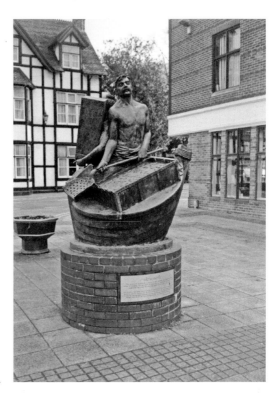

The Saltworkers' statue in Droitwich.

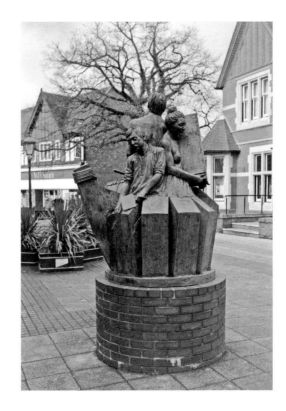

is unique; there is nothing to compare it with. If these are storage pits it is tempting to think that salt, a vital if small part of their diet, was in one of these shallow pits.

After becoming farmers the next logical step was trade. Crops, wool, cloth, hides, tools, fuel, pots, trinkets, spices, and, of course, salt, were transported along new tracks, routes laid out between settlements and arteries as vital as those between different places as motorways and trunk roads are today. The rarer the product the more value it carried and, for those who lived away from the sea, salt was the one item they found it hard to find. Indeed, even at the shore the concentration of salt in the sea means one has to evaporate a lot of water to get a little salt. So, when it was discovered that great sources of concentrated brine were bubbling to the surface at various points around Britain, the traders were quick to take advantage of this commodity.

The sources of salt were few, although clearly being an island and surrounded by salt water helped those on the coastline. Inland some salt was extracted in the northeast around Teeside, another long term source was found in Somerset, and later another mine was excavated at Carrick Fergus in Ireland. However, the two main sources were Cheshire and Droitwich in Worcestershire and these will provide the focal points of our journeys.

These deposits come from an ancient sea, which was flooded and dried out as land and sea levels fluctuated during the Triassic and Permian geological periods around 220 million years ago. This left a bed of salt which naturally is deepest at the lowest depths of the sea. It is this band of salt, many feet thick, which is all that remains of the nameless sea which covered a huge swathe of the country from Teesside in the northeast across to Cheshire, Shropshire and down to Somerset and Dorset, with the western edge reaching out as far as Northern Ireland. Those who maintain that common salt is not as good as sea salt should note the huge salt deposits in Britain are all derived from some of the oldest seas on the planet, salt laid down when the seas evaporated long before it had a chance to be polluted by burning fossil fuels. Indeed, many of those life forms which provided the fossil fuels had not yet existed.

This ancient sea was enclosed by dunes, for Europe was then much further south, close to the equator and a hot sandy desert extended across much of the world's smallest continent. The planet's crust is not solid but made up of several tectonic plates, areas of the fractured crust which float on the liquid magma at the earth's core. Slipping and sliding against, over, and under one another along fault lines, these are the reason for earthquakes and the hotspots for volcanic activity. Creeping northwards at just inches per year, the basin was repeatedly flooded and evaporated under the burning sun.

Other outcroppings of the salt have been discovered in Essex and Lincolnshire; doubtless this extends under the North Sea and has been mined on the Continent at sites such as Lorraine in France, De Panne in Belgium, at Hallstatt and Hallein in Austria, at Halle in Germany, and at Krakow in Poland. Note these names, Halle, Hallein and Hallstatt are all from the Celtic *hall* meaning 'salt'; the Hallein Salt Mine is in the region of Salzburg, meaning 'salt castle'. The same word is also seen in English place names Halsall, Halstead and Halwick. Another link between the Celtic and German comes from the Celtic *grava* meaning 'grey hairs', once used to describe those Celtic officers responsible for regulating salt and which is preserved in the German title Graf, the equal of a Count or Earl.

Part of a salt pan.

The extent of the salt brine lake beneath Droitwich has never been understood. However, the two points of extraction, at Droitwich and Stoke Prior, are undoubtedly fed by the same source, for it was shown that they were always at the same depth and of the same concentration. These figures never changed, no matter how wet or dry the season.

Gathering salt began in prehistory when sea water was evaporated by throwing it on to hot rocks around a fire and scraping off the resulting crystals. Prior to the arrival of the Romans, the Britons were evaporating brine in pottery pans supported on mud bricks over a wood fire. These pans were approximately two feet square and approximately half an inch thick; clearly these dimensions show the pans were produced solely for salt production as they would have been virtually useless as anything else.

The Romans arrived and produced their own pans, made from lead. While lead may have been more practical, not only longer lasting but also with more efficient heat transfer, today we would also question the wisdom of using a metal which would have brought the real danger of lead poisoning. One Roman salt pan is on display in Warrington Museum, measuring approximately three feet by one foot and six inches deep.

The majority of routes we shall be following are based on evidence from the later Saxon era and a Saxon pan has been uncovered too. Measuring two feet square and three inches in depth, this would have held seven gallons of brine and produced fourteen pounds of salt. We know from Domesday that a fully laden horse carried fifteen boilings

which, when multiplying this out, comes to approximately two hundredweights and thus a train of ten pack animals carried a ton of salt overland.

Each packhorse carried eight of the conical containers which characterise Droitwich salt, four on each side. As salt is so readily soluble it is these containers which mark the salt as being from Droitwich, an important clue when there are no recorded salt rights. These containers were called mitts and were common during medieval England; another example of a measure of dry goods by volume rather than weight. Unlike other measures such as bushels and pecks, used to measure grain, a mitt was only used for salt and hence would have been always around two stones or twenty-eight pounds in weight.

Even if the salt had survived to the modern day it would have been difficult to state exactly where it had come from, yet evidence can be found. Documented records of settlements with salt rights show that place names refer to salt in the roads, hills, streams and stopping places along the distribution network, and archaeologists have discovered evidence of the baskets or mitts which carried the salt. Such archaeological remains have been found at thirty-five sites in England, while Domesday quotes sixty-eight other manors with rights to receive salt from Droitwich, none of which are more than a few miles north of the town. This shows the settlements north of here received their salt from an alternative source, which is clearly the Cheshire wyches. It is clear there was no healthy competition between the two; the lines had been drawn early by the Saxon feudal system and were not crossed.

Sometimes, salt was linked to a single destination and it takes a little detective work to find out the association. For example, north of Redditch in Worcestershire is a Salters Lane which appears to be heading for Bordesley Abbey. This is the only road or lane out of fifteen documented between 777 and 1042 which cannot be placed on a known salt route. Furthermore, there is no reference to salt rights for Bordesley Abbey in any of the usual documents. Yet the trail can be followed between the two places, linked by Christianity.

In a charter bearing the seal of Richard I, the gift of land at Droitwich is made to Bishop Simon (1125-50) of Bordesley Abbey. Along with the land came the salt pit, while in a contemporary document the annual value of the salt to the abbey (while the source is not named) is given as £4 8s.

Such routes did not simply run from A to B but, like the tributaries of major rivers in reverse, filtered out into an array of routes and thus served whole regions. Furthermore, these tendrils often weave intricate patterns and interchange. These were not bus or train routes and did not follow either timetable or the same route every time. To show this, we shall be travelling alternatives branching off from the main route.

While there are no maps of the early routes, we can safely assume that the roads of today naturally follow a line at least close to the earlier tracks. Stand back and take a long look at any map of the country and see how A-roads, canals, and railway lines all follow similar paths. Not only do they avoid the obvious hills and mountains, the valleys and rivers, but take every opportunity to stay on as even a path as possible.

Engineers are well aware how much it costs to go over or through an obstacle when compared to a flat plain or nice gentle inclines, while any cyclist or walker will soon feel the hill. Similarly, the earliest travellers were in for the long distance and would

have taken the easiest path, through a valley cut by the river, or along the ridge of higher land and away from avoiding the wetter lowlands. It is difficult not to see the wild animals following the same routes, moving from one feeding ground to the next as the seasons progress. Keep this in mind as we follow a number of routes across the country in the following pages; it will make the reasons for each track easier to understand and follow.

This book not only contains details of the salt routes, but also looks at some of the people and places for whom salt extraction was a way of life; a very tough way to earn a living indeed. We shall also look at some of the uses of salt and, as we will see, how this simple compound is linked to so many aspects of life in the modern era, throughout recorded history and long before. We shall see how it affected cultures, empires, language, economies, and even the climate.

In the preparation of this book sincere thanks are due to the staff at the Salt Museum at Northwich, Droitwich Spa Heritage Centre, Droitwich Library, Cheshire Record Office, Worcestershire Record Office, Chateau Impney, and to the numerous guest houses who provided a tired and hungry author with a comfortable bed and a hearty meal.

2

DROITWICH TO WARWICK

When tracing a salt route nothing helps more than having a road called the Salt Way. While this may seem optimistic, there is just such a road coming from Droitwich and heading east. While there is no real starting point, the valuable consignment will have been stored ready for distribution and thus the workings would have covered a sizable area; it is difficult not to home in on the area around the modern spa.

Thus we embark on a journey beginning opposite the Raven Hotel at the statue by John McKenna in Victoria Square. Here is a modern depiction of a family of saltworkers, based on local people who were descendants of those known to have been employed at the works. This work demands a little attention, for the upper portion perfectly reflects the hardships this nineteenth century family faced every day. The lower images also manage to combine an, albeit brief, education of how this salt was produced.

Standing at the statue puts us within a loop of the present Salt Way, although this is a recent creation and the early route followed the lines of the Roman roads which are still marked on almost every map. It is to the meeting of these Roman roads we shall head and, thus keeping the Raven Hotel ahead of us, we turn left along St Andrews Road then, immediately after the road turns sharply to the left, turn right along Rickett's Lane and the Salt Way lies at the end of here. In front of us is the vista of the site of the earliest settlement of Droitwich, now the church of St Augustine's overlooking, no less, four modes of transport. We are standing on the trackway which certainly pre-dated the Roman road. Ahead of us is the Salwarpe, a river which would have enabled early man to transport the salt and later was made into a canal. The project was never completed as was first envisaged; Droitwich canal never reached the Worcester and Birmingham Canal until recently, when local pressure revived the canal and made it what it is today. Finally, there is the railway line, barely visible from here until a passing train reveals its location just above our line of sight.

Turn right and follow the B4090 to the crossroads with the Icknield Street and keep heading east. About a kilometre from our starting point we pass under the motorway

The Salt Way towards
Feckenham and Droitwich.

and emerge into rural England. This stretch of road is known as Hanbury Road, speaking of its apparent destination and then, before another kilometre has passed, come to the wharf where the Droitwich canal would have met the national network. Having crossed the railway line the road continues to gently undulate in a straight line until reaching Mere Green. Here, the modern road takes a detour from its course, heading towards the northeast. However, historically the road will have continued straight on across what is now farmland. Many years of farming have obliterated all traces of the road for the next four kilometres and yet there can be no doubt it existed, for the road continues on exactly the same line thereafter.

The detour takes us towards Hanbury, to meet the road to Bromsgove. However, it does give an early opportunity for refreshment at the Vernon Arms, if required, and only adds 300 metres to the overall distance. The slow descent to Bradley Court marks where we rejoin the original route and, on for less than two kilometres, to where we arrive at the historical village of Feckenham. Today this is little more than a small village, but was once the seat of a court which held sway over the whole of Feckenham Forest. In the

Junction of the Droitwich Canal and the Worcester and Birmingham Canal.

St John the Baptist church at Feckenham, which must have seen something of the salters as they travelled these roads.

thirteenth century, it covered most of Worcestershire, but 300 years later had dwindled to little more than an estate and was declared common land by the Crown.

In July 2006, as locals were planting new trees on the village green, a scroll was uncovered. It was claimed this document was issued by Henry VIII eight hundred years previously. Furthermore, it was said to contain evidence that the village would always be independent and would be exempt from national taxation laws. The document had hit headlines before it was revealed to be a hoax, merely a little known part of the forthcoming village festival. Yet by this time, the village had basked in the spotlight and carried through with their plans, which included a flag, t-shirts, and a complete appraisal of taxation including that of tax on alcohol. Interestingly, this was particularly welcomed by the licensee of the local inn, who seemed to have a great deal of knowledge on the find.

Continuing east from Feckenham, within two kilometres the Salt Way reaches Shurnock Court, an exceptional sixteenth century timber-framed building which is still a private residence. Here the road performs an odd loop before continuing on in a straight line once more. The two routes do not align, nor are they quite parallel, and the reason

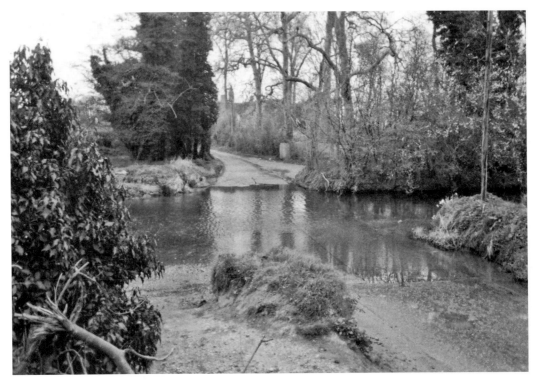

Ancient fording point of the River Arrow on Coughton Fields Lane.

for this diversion is not clear in the modern landscape; indeed, there may never have been one, although the straight line does lead on to Coughton Court and the remains of an ancient cross. This cross, today little more than a stump, marked the point where travellers entered the ancient Forest of Arden and would offer up some prayer or other pre-Christian rite in the hope of safe passage. Despite what Hollywood would have us believe, not all outlaws lived in Sherwood Forest and, even today, traditional practices should not be ignored.

Thus it seems more likely that the ancient salt route headed directly from Shurnock towards Coughton Court, a journey of five kilometres. However, the modern road takes a detour here and, unless the traveller is prepared to follow a complex number of bridleways and public footpaths, it makes more sense to continue along the modern route of the B4090. However, if we do follow the Salt Way it ends at what is today marked as the A441, the road to Evesham, which is better known as The Ridgeway. However, the route does continue along the B4090, where the road is known as Alcester Heath, to emerge at the junction with the A435 still known today as Ryknield Street. This Roman road is not a Roman name, but one which is actually taken from another Roman road, the Icknield Street, and has no true etymology in the normal sense.

Here we should dwell for a while on the importance of Roman roads in travel across the country. The Roman Empire arrived in Britain in AD 43 and, during the next four centuries, improved technology and the standard of living for the tribal leaders and

Crossing the River Alne here could never have been easy, even when the water level was low.

noblemen already living here. For years it was believed to have been a bloody and vicious conflict, personified by the tales of Bodicea and her followers. However, it has recently become clear that the Romans were actively encouraged to come to Britain by the tribal chiefs, who could only benefit from their arrival. Yet the farming community and the peasants would, at least initially, have hardly benefitted at all. Furthermore, we also know that Britain was not the barbaric island stated by the Romans; the Celtic peoples had a thriving culture and were already trading with much of the known world, while the wondrous technologies associated with the 'Romans' were invariably assimilated by them from other cultures. Indeed, it is true to say the culture during the occupation should be regarded as Romano-British; still ostensibly Celts but with ties to the Empire.

While there is no doubt that the Roman roads were a tremendous boon to the nation, well surfaced with previously unheard of drainage ditches, the routes would have been in existence since the times when man first settled to an agrarian lifestyle instead of nomadic hunter-gatherers. Trade, particularly in salt, was a necessity for these settlements and so to mark the routes to their doors made sense for, if nobody knew where the hill-fort settlements were, the occupants would soon run out of vital commodities. Thus it should be seen that the roads were surfaced by the Romans, but the routes were already well worn and had probably been so for at least five thousand years before the Romans arrived.

The Edstone aqueduct crosses the salt way, looking a little more fragile from below!

Of course, irrespective of the surface, the travellers and their goods followed the same routes to the same places and thus the junction of the Salt Way with Ryknield Street should be looked at from a different perspective. Indeed, while the road from Droitwich certainly headed off to Coughton Court and perhaps on to Stratford, Leamington or Warwick, the salt route more likely turned south along the Ryknield Street and the meeting point between the two should be seen as a crossroads, with traffic to the crossroads from both east and west. Today a public house stands at the junction of the Salt Way and The Ridgeway, and there is the Throckmorton Arms at Coughton and certainly others in the past. Such sites were often used as staging posts, as distribution points for goods; effectively an early warehousing and distribution system.

For the time being, the route to the south will be followed and thus on reaching the Ridgeway turn left, and then immediately right along the B4090. From there, follow the road around to the right and along Alcester Heath until, after a distance of two kilometres from the A441, Coughton Lane is a narrow road turning off on the left. This brings us to Coughton and the ancient marker cross and Ryknield Street. There are no surviving footpaths between these two major junctions; indeed, the salt route could well have followed a similar path to the modern route. It is worthwhile examining the cross here, today surrounded by spiked railings to prevent damage to such an ancient monument, and reflecting on how long this has marked this important junction. For

Here the Edstone aqueduct carries the canal across the railway, the River Arrow (behind the trees), and the salt road – four modes of transport!

the adventurous, nearby Coughton Court and its associations with the Throckmorton family and the Gunpowder Plot is a worthwhile diversion, should time allow.

For us the route turns, ignores the road south along Ryknield Street and continues along the country lane which crosses the ford and passes Mill Ford, here becoming known as Coughton Fields Lane. Unlike the Roman road of Salt Way we travelled after leaving Droitwich, this is a meandering country lane and one which is easy to see as being picked out through the boles of the trees of the Forest of Arden. However, the ford marks the point where we shall head off road and follow Arden Way, a bridlepath which crosses the fields past the copse near Windmill Barn and rises to the road at Spernal Lane some three kilometres away.

Sometimes the most innocuous of locations can give clues to the past and this region around Alne Wood, clearly visible to the left and northeast of us here, is just such an example. Three roads here, Spernal Lane, Shelfield Lane ahead of us, and Burford Lane to the north are recorded in a deed of 1282-1314 as Spernowe Way, Schelfhullway and Warwikeswaie respectively. Furthermore, and this is of great interest to us, it also refers to a Salters' Oak on the road between here and Bearley Cross which we shall come to shortly. Unfortunately, this is the only reference to this point and, as no maps survive showing its location, can only be guessed at. However, this is local knowledge and must be accepted as more than coincidental.

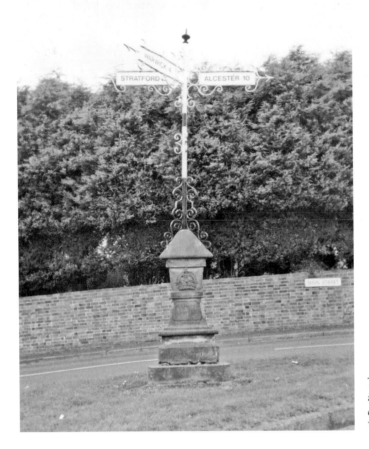

The base of this signpost at Norton Lindsey commemorates Queen Victoria's Diamond Jubilee.

At Spernal Lane is New End Farm and directly opposite is the road to Shelfield which we take and follow it as it bends right after 500 metres and becomes a part of the Heart of England Way. Follow this as it bends to the right and eventually reaches Glebe Farm. Here the road bends sharply left and to the north, while ahead of us is another of the National Trails; this time it is the Monarch's Way.

Following this well marked leisure route takes us away, across gently rolling English countryside, towards Little Alne two kilometres away. On reaching the road, Little Alne is to our left and we walk through the hamlet before turning left along White House Hill. This is also known as Bearley Road, although much of it is unnamed in the landscape. Follow this road for 500 metres, ignoring the road to Aston Cantlow on the right and turning left just before Whitehouse Farm. Another two kilometres further and we pass underneath the aqueduct carrying the Stratford-upon-Avon Canal and shortly after beneath the embankment of the railway line from Birmingham's Tyseley Junction to Stratford-upon-Avon.

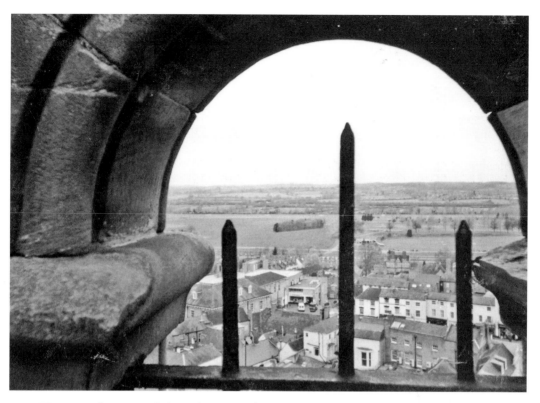

West towards Droitwich from the tower of the Collegiate Church of St Mary at Warwick.

This line was saved from closure several times, much to the delight of the author's former headmaster who travelled this line to Yardley Grammar School every day and was late but once, when there was a cow on the line. In the twenty-first century, the Shakespeare Express takes steam enthusiasts on weekend specials between Birmingham and Stratford-upon-Avon (and indeed back) and a most sumptuous three or four-course Sunday roast is available to those who wish to dine in style. Unlike many heritage lines this is still a mainline track and, as such, enables the steam locomotives to haul its train at speeds of 75 miles per hour, faster than the cars (should be) travelling on the M42 and M40 motorways nearby.

Just before the aqueduct, Newnham Lane led off to the right, this marks the point where the road known as White House Hill becomes Salters Lane and heads towards Bearley Cross and the A3400, where after it becomes Langley Road as it heads towards Langley Green.

Bearley Cross offers refreshment in the form of the Golden Cross, while for the train spotters Bearley Halt is less than a hundred metres away. Indeed, as we follow the Langley Road it almost parallels the route of the railway line for over two kilometres before passing beneath the line and diverging away to the east. From here there is another four kilometres of largely uneventful, undulating road approaching ever-nearer to the town of Warwick, which brings us to Norton Lindsey. This village sits on the lower slopes of

Ward's Hill and at the junction of Main Street, Warwick Road, and Wolverton Road is a delightfully ornate fingerpost. While it has no connections whatsoever with the salt route, it does show how a little thought can produce a memorial which is tasteful, informative, and useful. The scrollwork is functional as well as decorative, while the base is engraved with the dates of the birth, coronation, wedding, and death of Britain's longest-reigning monarch, Queen Victoria.

We shall be following the pointer to Warwick along, somewhat predictably, Warwick Road. Before long we cross the M40, one of the newest in the motorway system and connecting the ring around Birmingham with that of the nation's capital city. It is worthwhile reflecting as we cross the busy road that we are standing above one of the country's busiest modern roads, while travelling its counterpart from pre-history.

3

DROITWICH TO LECHLADE

Standing alongside John McKenna's sculpture of the salt workers in Droitwich, it is easy to see why the sculptor chose to represent the workers rather than the more famous figures in the town's salt history. It is quite striking how the artist has managed to recreate the dire working conditions within the expressions of the family.

The sculpture stands next to the present-day library, built on the site of the former Salters Hall. The hall was constructed by John Corbett – the Salt King – to provide a local venue for concerts, dances, and lectures. This was demolished in the 1930s to provide room for the new cinema, itself pulled down in the 1960s, and the library now occupies the site.

Directly opposite is the Raven Hotel and we shall cross towards this, then turn right and take the St Andrews Road round to the left at the mini roundabout and, within a hundred metres, reach the crossroads formed by Corbett Avenue opposite (another reference to the Salt King) and the Worcester Road, which we turn right on to. Before long, we come to another island and turn left to continue along the Worcester Road for almost a straight mile along the Roman road to the large traffic island junction with the A38. Continue along the trunk road in the direction of Worcester until we have travelled approximately two miles from our starting point and come to the Swan Inn at Martin Hussingtree, which offers a good selection of food.

Martin Hussingtree first appears in a document of 1327 and prior to that these were either two distinct manors or given as Hussingtree with Martin. Indeed, Domesday ignores Martin as a place name, but includes the region with Hussingtree. The road to the left heads south towards Pershore. Today designated the A4538 and named Pershore Lane, it has traditionally been known as a salt way locally, even if that name never seems to have made it on to any map of the area to have survived into the twenty-first century.

Two miles down a road which can be described as direct rather than straight, crossing the Worcester and Birmingham Canal which would have carried salt in its youth, we

then arrive at a junction and a sight which would have terrified the salt carriers, but one which is as important today as our chosen path was to them. As we take the island around to continue on the same road to Pershore, note that this is the extreme northeast of the city of Worcester. Beneath us is the M5 and it is worthwhile pausing to note that the speed of the traffic beneath takes those travelling today the same distance in twenty minutes as the salt traders would have managed on a good day. Walking these routes today we can travel twenty miles by keeping a reasonable pace, yet even with pack animals bearing the load the ancient tracks were unlikely to allow travellers to match this on all but a few days.

All around us here are signs which the salters could never have imaged. To the southwest is the tower of Warndon parish church of St Nicholas. Restored in 1991 to serve the new estate of Warndon, it was founded in the fourteenth century to serve the then village of Warndon. Its most striking feature is the wooden tower of solid oak frame and plaster infill, a Tudor style which houses three bells, the oldest of which is the six-ton tenor bell cast in 1440 by John de Belfrere of Worcester, and bears the inscription *Sancte Gabrihelis Ora Pro Nobis* 'Holy Gabriel, pray for us'.

On our left is a ridge of trees known as Coneybury Wood, which obscures the view to Tibberton beyond. While the salters may have seen trees here, it would not have been known by this name. Indeed, this name would not have existed before the Normans arrived, for they brought the rabbits or coneys with them to England which gave the wood its name. Ahead is almost two miles of gentle country lanes, broken only by the lanes leading to first Tibberton and later Bredicot and Crowle.

For the last mile or so this road forms the eastern boundary of the parish of Spetchley. A charter dated around 985 mentions this road and is notable, for it states 'to the west is the salt street to Spetchley boundary'. The road does lead to the south eastern boundary and, having crossed the railway line, reaches a junction where the modern A422 and A44 meets our Pershore Lane route. This is where the road linking Droitwich and Evesham crosses that between Worcester and Stratford-upon-Avon, a point marked as The Crossroads and a name which tells us more than is first apparent. This is not Spetchley Crossroads or any other named place but THE Crossroads and probably the first of many points along this route where salt was traded, a distribution point feeding the many villages and hamlets around here.

Travelling further south along the A44 towards Pershore, just half a mile along we arrive at the Nightingale public house at Sneachill and by the time we have gone a mile from The Crossroads we reach Low Hill which, rather ironically, is 30 feet higher than either Sneachill behind us or Egdon or 'Ecga's hill' ahead. The charter of 985 confirms the route passing Low Hill and mentions Oswaldslow to the west, a place name which no longer appears on modern maps, but which does explain why the Low Hill is higher on this route. The word comes from Old English *hlaw*, here with the personal name showing past ownership, which speaks of a tumulus or burial mound. The mound was ploughed out centuries ago but, as stated in the charter of 985, this was 'Oswaldes hlaw alongside the salt straet'.

On reaching Egdon the Berkeley Arms is on our right. This is named after the family based at the Spetchley estate who are first recorded in this area when Richard and Alice

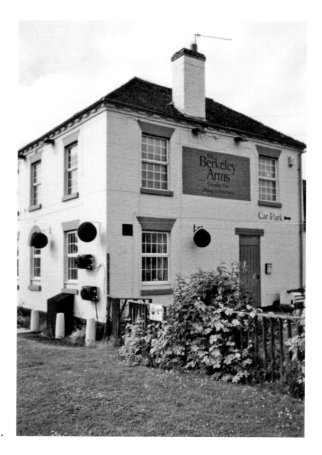

Berkeley Arms at Egdon.

Andrews sold it to Robert Berkeley in 1612. The Spetchley estate is still held by the family, the latest in the long and unbroken line being Robert Valentine Spetchley.

Looking back, the land can be seen to rise to Low Hill and, while the names are no longer noted on modern maps, history shows the road from Low Hill was referred to as *salt herpath* 'the salters' path', which leads to *saltere dene* 'the salters' valley', and then to *saltere wellan* 'the salters' spring or stream'. Poking our head over the hedge on the left we see another reminder of this ancient salt route in the Saw Brook. The name of this stream is slurred *salt broc*, itself an abbreviated *Saltere broc* or 'the salters' brook'. The original name seems to suggest the Salt Brook was saline, when it really speaks of it being associated with those who transported this commodity, the salters.

Of course, a mention of salt would instantly make us think the brook was used to transport goods on rafts or small boats, particularly as the route will take us to other rivers in this system. This is only a brook and not a practical method of moving anything. However, the road and the brook follow a similar route even today, hence there is no actual link between the brook and the salt route; although it is more than likely this is where the pack animals would take a well-earned rest and a drink from what is still the clear, sweet waters of the brook, which in no way merits any idea of it being 'saline' as the name suggests.

Elmley Castle Cross looking towards Bredon Hill.

While the brook meanders away from the road here, the road continues to head southeast. Passing Peopleton to the east we pass through Stonebow and the road towards Drakes Boughton and on to Pinvin, some three miles from the last pub at Egdon. This is a small village which has been developed as a trading estate north of Pershore. In the days of the salt route there was a side route south to Pershore which left the road here; indeed, there is a note of the town having salt rights to Droitwich salt equal to one salt pan. The size of the salt pan could vary; here it was said to be around 30 mitts or summae.

As with so many ancient measurements there was no standardised volume or weight for a mitt or summa, yet it was said to be a cart load. Clearly this depends upon the size of the cart and, in turn, the number of horses pulling it and yet there are known limitations to the size and weight as we know the state and size of the roads. Thus it has been possible to estimate the mitt, or summa as it became known at Droitwich, as equal to eight bushels.

While the bushel is another obscure measurement, those old enough to remember the tables of imperial measurements on the rear of school exercise books will have heard of it, even if we never actually used it. However, here we run into another problem, for the bushel was as much a measurement of volume as it was weight and thus could

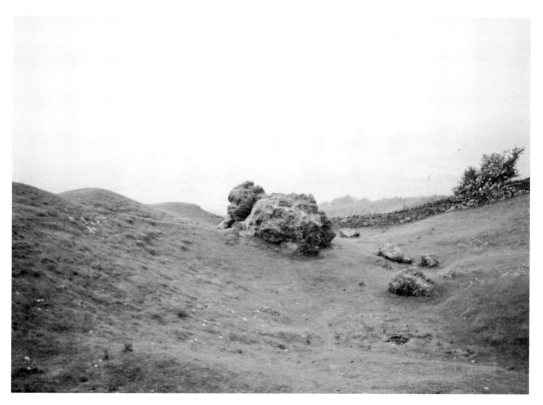

The Bambury Stone on Bredon Hill, said to resemble an elephant and be covering a fabulous treasure.

vary depending upon what was being weighed. A bushel of oats was approximately 14 kg, while a bushel of wheat or potatoes was twice that. Suffice to say that Pershore's allocation of salt was ample for the population.

Our road takes us further east to Wyre Piddle, while the salt to Pershore would have headed south along what is now the B4082 and meets up with the B4084 in the centre of the town. If this road is followed south past Pershore's marvellous abbey and down to cross the Avon at Pershore Bridge and thereafter west towards Cropthorne, we will meet up with the original salt route which, as we shall see, no longer offers public access to the ancient crossing point on the Avon.

Continuing along the road from Pinvin, heading towards Evesham through Wyre Piddle, we come along Main Road where it almost parallels the Avon, until it becomes Evesham Road from the junction with Chapel Lane and is approximately a mile from the crossroads at Pinvin. Continue on and take the second road on the right; this lane is still called Salters Lane today and, as it leads nowhere other than directly to the river, is another clue to the route. Looking along the lane one quarter of a mile away is a footbridge across the Avon and the site of *Piriforda*, only known from the charter of AD 985 and a name which seems to refer to 'the ford of or by the pear trees' or perhaps the first element is a personal name. The path in front of us does not have public access and to attempt to cross

here is foolhardy, for sadly there is no way to cross the remaining 400 metres to rejoin the previously mentioned B4084 after it emerges from Pershore and passes Wick.

Hence we are forced to either take the footpath towards Fladbury or to return to the Evesham Road to Fladbury Cross and right into Fladbury itself, depending upon the mode of transport. The footpath brings us to Coach Drive which we follow to the junction with Station Street, meeting up with the road alternative and following it right, and then taking the left fork of Church Street and Mill Bank to take us across the Avon via the Jubilee Bridge. Turn immediately right along the delightfully-named Neigh Lane and right again on to Main Street through Cropthorne and then Brook Lane to return to the B4084. From here follow the Wychavon Way south, signposted to Elmley Castle; alternatively, turn right and then first left towards the village. This route can also be followed if taking the route through Pershore; however, ignore the first turn on the right, also marked Little Comberton, and take the second shortly before Cropthorne.

This road runs almost perfectly straight south for approximately one mile before reaching a T-junction. Here the route splits in two, until they are approximately half a mile apart, and then they head south on parallel courses. This seems to be an odd feature and is clearly unnatural for the lines are too straight and the angles are too sharp.

Furthermore, these roads eventually meet up again a mile south just before Elmley Castle; however, if the original road is extended through the T-junction it virtually hits the place where the two lanes meet. It is virtually impossible not to believe the direct route was the original path, while today there is no surviving logical reason for the re-routing of the road to both east and west, at least not in the landscape.

Historically the route may have taken a route to the south along a line a mile or so east of this road. Evidence comes in the form of maps which suggest there was a track marked *Saltway* and *Ealdan Staet*, along which was *Salters Barn*. However, the accuracy of the map is questionable and, without further evidence in the landscape, seems an unlikely path suggested as this route eventually follows a line roughly equivalent to the border between Warwickshire and Gloucestershire. If desired the road from Cropthorne can be followed on foot via Wychavon Way from the road to Evesham. There is then a distance of three miles passing through Netherton, where there are remains of an old chapel, to rejoin the road south of Elmley Castle.

Having taken the road through Elmley Castle and entering the village from the north, at the exact point where the two lanes rejoin, is a point marked on the map as Bess Cap. This point is linked to the name of the Queens Head public house, where Elizabeth I is said to have stopped. The Virgin Queen, last of the Tudor dynasty, having travelled from Pershore entered the village at this point. Here she was said to have been presented with a hat by the villagers to mark the occasion, hence the name of Bess Cap.

Almost in the centre of the village is found the remains of a stone cross. With much of it hidden beneath the ground, its age and significance is a mystery. Ahead is the church of St Mary and behind looms Castle Hill, rising to over 600 feet above sea level, and between us are the steep slopes where the ruins of a Norman castle, which gave the village part of its name, sit in the Deer Park.

Turning west here past Manor Farm to follow Hill Lane, the road becomes a public footpath up a long gradient towards the ridge along the top of Bredon Hill. This is not

part of our route, but a significant historical detour, for this was the site of a hillfort and would have been a target for the salters of pre-history even if there are no surviving records or evidence in the landscape to confirm this. The name of Bredon Hill has three elements, each from a different language: the first is the oldest from Celtic *bre*, next is Old English *dun*, and lastly Middle English *hyll* and all three with the same meaning. Thus, this is a place name meaning 'hill, hill, hill'.

Reaching the top of the ridge the footpath to the west is clearly marked and the tower, quite rightly known as Parsons Folly, is soon seen as our obvious destination. Modern maps show Bredon Hill peaks at 293 metres, offering views down upon Castle Hill, and a measurement which is of little significance using the metric system. However, in the second half of the eighteenth century, John Parsons would probably have no knowledge of metres, either in his capacity as Squire of Kemerton or Member of Parliament for this place. To Parsons, this was a hill rising to 961 feet and so he built a summer house on top of the hill, a building now used to support an array of aerials, which added 39 feet to the total height and made it hit the magic one thousand feet – although officially it is no higher today than it was when Iron Age buildings were erected here.

Just below the folly is Bambury Stone, an oddly-shaped outcrop of a conglomerate rock, which is said to resemble an elephant – and indeed, it does seem such when standing to the rear left. Tradition has it that a fabulous treasure lies hidden beneath this particular pachyderm, which can only be reached when the great creature rises from his vantage point on hearing the clock at Pershore Abbey strike midnight; the signal for him to descend the hill to the Avon for a much needed drink.

While it is considered to be good luck to kiss the Bambury Stone on Good Friday, the earlier religion of the Druids was said to utilise this stone as an altar. Below the summit are the King and Queen Stones, where the sick were laid between them in order to cure them of many ailments. Locals still maintain it is a site of great interest to those with an understanding of witchcraft and the occult. On the wet and windswept day of the author's visit there was no sign of a coven. However, the arrangement of smaller loose stones on the grassy bank sent a message readable only by low-flying aircraft or passing hang-glider pilot, revealing 'LEANNE 4 ASH'.

Back at Elmsley Castle's church, home to monuments of the Savage family and Thomas, 1st Earl of Coventry, take the road southeast, passing The Old Mill public house, although no trace of the watermill itself remains here. Shortly afterwards, we meet up with the Wychavon Way which, if on foot, can still be followed down to Ashton-under-Hill in order to continue the route, although there is no suggestion this is the original saltway. Indeed, continuing along the road past Kersoe, we approach a region said to be the location of a salter's well on the boundaries of Hinton-on-the-Green in a charter of 1042. It has to be said there is no surviving map or other record of this well and the location of the boundary and/or the well is questionable and cannot be used to trace the route.

Passing Kerson the road turns sharply to the left and then right and right again, taking us in a loop around Furze Hill and into Ashton-under-Hill from the north. There are two stopping places in this most scenic of villages; the first is in the field on our right of the lane as it takes a long sweep to the right, shortly before the village proper and has no links to the salt route.

Britain was at war and mid-morning on Friday 16 July 1943, a Lockheed Hudson Mk IV left the runway at RAF Defford. Aboard were two men: Squadron Leader James Mead and Pilot Officer Allan Slaughter. Moments later, the pilot reported he was experiencing engine problems and, just fifteen minutes after take-off, the aircraft hit the ground in this field north of Ashton-under-Hill.

Coming through the mile-long main street through the village, we pass the war memorial and come to a fork. We shall be taking the left path here, still known as the Salt Way, but first look back to the village cross and the church dedicated to St Barbara. Parts of this place of worship are at least Norman and thus nine centuries old, although there have been many other phases of building since. This is thought to be the only church dedicated to St Barbara in England; perhaps she was chosen owing to her reputation for affording protection from lightning strikes? This is also where we rejoin the Wychavon Way for those who followed this alternative route on foot.

We go onwards, firstly to the left and then immediately right and cross the Carrant Brook, a tributary of the Avon at Tewkesbury, and a river name of some interest owing to its links with pre-history. Listed as Rivuli Carent in 779, Karente in 1274, Karentam in 1318, Caraunt in 1482, and Carrants Brooke in 1626, one of the delights in defining a river name is in finding comparable river names elsewhere in Europe and across the Indian sub-continent. This is evidence of the origins of the vast majority of the languages native to these regions, evolving from a Proto-Indo-European which is said to have existed anywhere from 6,000 up to 12,000 years ago depending upon the school of thought. Similar river names are seen in Europe with Charente and Karantona, both from the Celtic *carant* and related to Welsh *car* 'friend' and referring to the 'friendly or pleasant stream'.

Crossing the bed of the disused railway line to Birmingham we continue to follow the line of the Wychavon Way until it leaves the lane; thereafter the choice depends on the mode of travel. Both footpath and tarmac routes lead to the Evesham-Tewkesbury Road or A46, although between here and Toddington the route is difficult to mirror, other than on foot. Thus the road route will lead off along the road signposted to and through Dumbleton, from which a right hand turn at the junction takes us down to the crossroads and then a left for Toddington itself.

Meanwhile, the route of the Wychavon Way will lead us south along the path taken by the salters. This will take us from 150 feet above sea level at the road almost to the summit of Alderton Hill, just over 500 feet above us. At first the path leads along the gentlest of gradients, yet as we reach Didcot Farm the path inclines up and through Oxhill Wood and along the edge of the ridge formed by Washbourne Hill and Perretts Hill and around under the summit of Alderton Hill. From here the salters likely followed a more direct route to Toddington, yet present public footpaths make for a less direct path and thus we continue along the Wychavon Way south, down the slope to Frampton Farm and eventually we reach the road just yards west of the crossroads, reached via the road alternative.

This is the B4077; a left turn takes us off the Wychavon Way and a mile east into Toddington. It is worthwhile detouring into the looping road through the village, if only to visit the local inn The Pheasant and to look at the rather oversized church for

St Barbara's, Ashton-under-Hill. The saint who protects from lightning strikes, the lightning rod to protect the church is on the other side.

such a moderately-sized village. This is a detour taken simply to enjoy the architecture; however, there is another route which also leads to Lechlade and may well have been an alternative route, although it is impossible to say if the two were contemporary or which was the original. This route will be followed in the following chapter.

Another route is marked on a map by Landboc of Winchcombe in 1256, where the *Saltweie* took the precious commodity to Winchcombe Abbey. Salt rights were granted to Winchcombe before 1175 and, while the abbey was found in AD 798, there is every chance the salt was taken to Winchcombe prior to this, for there is evidence of habitation here from at least 3000 BC.

The present building of St Andrew's is the third church to occupy this site and was funded by the then Lord Sudeley; many of this family of Hanbury-Tracy are entombed here. Indeed, the lavish sculptures and ornate carvings contributed to the loss of the family's wealth and their departure from Toddington. This family had also spent money (well over £150,000) on the Jacobean mansion that is Toddington Manor, the ruins of which were denied being turned into an hotel in 2004 and were eventually purchased by the artist Damien Hurst. He plans to restore this Grade I listed building and use it as his family home, while also enabling him to display a collection of his own works and those by other artists in his possession.

At Toddington is the northern end of the Gloucestershire and Warwickshire Railway, a preservation line with big plans to link Stratford-upon-Avon and Cheltenham, which would make it the longest heritage railway in the country. While that is for the future, the line has played host to some of the most famous steam locomotives in history, including the *City of Truro*, the first engine to pull a train at over 100 mph, doing so in 1904, and arguably the most famous engine of them all, number 4472 *Flying Scotsman*.

While the steam railway line runs southwest towards Winchcombe, the B4632 parallels its course for a while and is the road which will take us back to the original salters' way. Before this, just a mile along the road and in a field north of the main buildings of Millhampost Farm, are the remains of a Roman settlement. This site has not been studied extensively; indeed, the plough may have destroyed much of the information here, to date limited to the finding of pottery fragments and a Roman cemetery. Opposite the road leads to Hailes, the remains of its famous Cistercian Abbey and the older and still intact church and its wall paintings.

The year was 1242 and Richard, Earl of Cornwall was caught in a terrible storm at sea. A pious man, he turned to the Lord, praying he would deliver him to safety and vowing that, in return, he would build a monastery should he survive. He was not without his contacts, his brother was King Henry III, and Hailes Abbey was completed by 1252. Cisterian monks were obliged to build their places of worship away from places of habitation. Yet here that was impossible and so there was but one answer, to move the village!

In 1270, Abbot John of Beaulieu visited and brought with him Edmund, son of the abbey's founder, who had a most precious relic. And so it was that the abbey came to possess a vial of blood, certified as genuine by the man who was to become Pope Urban IV and a guarantee this was to become a place of pilgrimage. During the Middle Ages, the faithful flocked here, until the Dissolution of the Monasteries by Henry VIII saw

The Salt Way, north of Roel Gate.

the removal of the vial. Taken to London by the new Protestant church leaders, the Bishop of Rochester declared it to be but 'Honey, clarified and coloured with saffron'. Others claimed it was the blood of ducks and had been replenished regularly since its arrival.

It is certain the abbey and likely the Roman settlement were stopping points for the salters on their route and, while no Droitwich salt containers have yet been found by archaeologists to show a connection, the evidence is firmly recorded in the landscape. For passing the remains of the abbey the lane becomes Salter's Lane and turns south, climbing the flanks of the aptly named Salter's Hill and heading towards Sudeley Hill.

From Hailes Abbey the route is still evident on modern maps and in the landscape. Indeed, for more than six miles this route is known as Salter's Way and then Salt Way. Salter's Hill is only a mile south of Hailes, not far from Haile on the Hill and the two hills are separated by a narrow line of trees known as the Larch Banks. Just before the tree line we cross the Gloucestershire Way, to the east of here is a site mentioned in several medieval documents as *Strip Lynchets*, a Saxon name referring to 'the strips on the ridge or terrace' and which are still quite evident even today, when conditions are right. It is tempting to suggest salt was supplied to the farmers here, yet there is no documented or archaeological evidence to substantiate this claim.

Continuing south along the Salt Way, after about half a mile we reach a road. While the Salt Way dog legs to the left here before continuing south, our interest is momentarily taken by the map reference to the west and where, on the slopes of the hill just below the trees, is found St Kenelm's Well. Also seen as Cynehelm, there are a number of differences between the legend and the known facts. However, both point to the man being associated with the nearby town of Winchcombe.

Kenelm was a Saxon saint mentioned in the *Canterbury Tales*, where he was a member of the Mercian royal family, murdered at the age of 25 by person(s) unknown on the Clent Hills to the north, not far from Stourbridge. His body was concealed but later divine intervention, in the form of a pillar of light, pointed its position out to a party commissioned by the Pope, led to its discovery and eventual transportation by the Monks of Winchcombe to a shrine where it remained for several centuries. In the past, the locals would look forward to the feast day of St Kenelm (July 17), when the highlight at the village fair was 'crabbing the parson', when crab apples were lobbed at whomever was currently serving as vicar.

Back at the Salt Way, the dog leg right is followed be a left only 50 yards further on to continue the journey south along the ridge of Sudeley Hill. For approximately two hundred yards it follows the road from Winchcombe before branching off to the right, where the Salt Way also forms the boundary of the grounds of Sudeley Castle as evidenced by the name of Outer Park Wall which is still marked on maps today. A mile along this road we are less than half a mile east of the remains of a Roman villa at Spoonley Wood. Archaeological evidence shows at least three different stages of construction; dating is difficult, but estimated at leaving this place empty by AD 400.

Passing the disused quarries we come to the crossroads known as Roel Gate, a name referring to 'the entry to the spring of the roebuck'. Just to the west, two hundred yards from the crossroads on the right and just over the very summit of the rise, is an old settlement. Little is known of this place, which is possibly an indication that its period of occupation was quite short. Stand here most days and the wind will soon make anyone want to move on; maybe this explains why the settlement was short-lived and also why the Romans built their villa much lower down.

Crossing straight over at Roel Gate the ancient Salt Way runs straight and fairly level for half a mile until reaching the well on Clayhill, to take the left hand fork towards Hawling. While the Salt Way follows the road on the right a further half mile along, it is worthwhile turning our attention to Hawling, for it would certainly have been a stopping place for the salters even if there is no written or archaeological evidence to support this.

As a village, Hawling is comparatively new; this is because the original village to the northeast was abandoned in the Middle Ages. There are two old sites here; entering the village, almost the first thing we encounter is the old Manor House on the right, immediately before the church of St Edward. Walking through the village, the evidence of the medieval village is still there in the landscape, to the north of the road at the edge of the modern village. Hawling was relocated as a result of sheep farming. Huge areas of Gloucestershire and the Cotswolds were given over to sheep farming and were the basis for the wealth of the region and indeed the nation.

Turning back to where the Salt Way headed off to the south, now on our left, we follow the lane south. As previously, we are now travelling the ancient salt route and even today it is possible to see glimpses of the countryside as it would have been all those centuries ago. This part of the route is quite direct, crossing the road leading to Brockhampton; west of here, in just over a mile, it meets the A436 heading for Andoversford. Turn right along the Andover Road and then immediately left where we will soon skirt Salperton.

The name of Salperton is relevant for, even though this tiny hamlet is a few hundred yards east of the Salt Way proper, the name tells us it was a stopping off point for the salters – the name means 'the farmstead of the salters'. Not that this suggests salt was being made here; however, it is possibly a point where fresh pack animals or even men make the over the journey from here, while it seems likely that some of the salt was distributed to the area from here. It is worthwhile noting that All Saints Church here is home to some quite excellent medieval wall paintings.

However, the real interest is to the west of Salperton where you can find the remains of a tumulus and an earthwork, while further along near a left fork in the lane are the marks of long barrows. Whether these were contemporary with the earliest days of the salt route will never be clear, although the two certainly would not have any connection. Doubtless the original salt route took the left fork here and yet, although there is a footpath which brings us back to the Salt Way when it re-appears just south of the A40, we shall take the lane to the right until three miles from Hawling we meet the A40 heading towards Cheltenham. Turn left here and travel the half mile to the next road on the right, this again is the Salt Way.

Just before here we pass the ancient Puesdown Inn. A pub has stood here since the thirteenth century, although it was only during its heyday as a coaching inn of the seventeenth and eighteenth centuries that the majority of the stories come. One tells of a highwayman who made a mental note of all who passed through these doors, weighing them up as potential victims when he donned the trappings of his true vocation. However, the coachmen had started fighting back, as it was in their interests to provide a reliable and safe service or they would soon have no customers and thus no jobs.

The Puesdown was in darkness by the time he arrived back. Mortally wounded in the exchange of gunfire, the highwayman managed to summon the strength to crawl up to the doorway where he collapsed. He was found next morning in this very spot, having bled to death as a result of his injuries. Over the following three centuries, there have been reports of an unseen rider galloping along these lanes, or of the shadowy figures of a horse and rider coming up the driveway and yet making no sound. One wonders if any of the salters heard ghostly tales within the walls of the Puesdown had they stopped here for refreshment.

Having turned off the trunk road between Oxford and Cheltenham, the road travels a mile southeast, passing tumuli and a long barrow after approximately half a mile to the north of the road. The road forks once more at the spot known as Hangman's Stone; nothing forbidding about this spot, it is simply the highpoint here. Take the road to the right and, in under a mile, reach the famous Roman Road of the Fosse Way. This route takes its name from the ditch alongside the road, a conduit which took water away from

the road surface. There is increasing evidence to suggest that many Roman roads were in use hundreds or even thousands of years before the traditional founding of Rome in 753 BC. Roman technology had provided a hard wearing weatherproof surface, but the surveying had been carried out many years before.

Hence the Salt Way and the Fosse Way form a crossroads here and must have been an important place on both routes. Although there is little evidence of this being an important point in history to be found, there is a name which shows the salters stopped shortly after crossing the Fosse Way. The Salt Way does not cross directly over at this point, that is a footpath which passes Northleach to the south. A few yards south along the Fosse Way is the lane which, half a mile further on, brings us to Saltway Barn.

Continue along this lane, ignoring the roads to left and right at the top of the hill and where there was a long barrow to the north. Further along we pass Saltway Farm and, shortly after we have left this line and turn south, a third name referring to the original salt route continuing southeast is another Saltway Barn. Taking the tarmac route, follow the road to and through Bibury and thereafter to Coln St Aldwyns. The public footpath follows a direct route across country, an easy walk of three miles with hardly any noticeable inclines and only encounters one other route, when crossing the road between Bibury and Aldsworth.

The two alternative routes meet up again just under a mile northwest of Colne St Aldwyns. Crossing a dip in the road the village ahead appears, tucked into a bend of the River Coln which gave its name. This road brings us to a junction north of the village; turn right and enter the village where the salt route continues, by turning right and following the signs for Hatherop.

There is an alternative route which can be taken by ignoring this turn and passing right through the village towards Quenington, turning left at the war memorial to meet up with the Salt Way once more south of Hatherop. While the Salt Way is not marked as such at either Coln St Aldwyns or Hatherop, we can be certain the route was to the former to the north, for there is an almost perfect alignment between the Salt Way before Coln St Aldwyns, and that after and south of Hatherop. This would not be a perfectly straight route today, for there is a loop of the Coln in the way and would mean fording it twice. However, historically this meander would have described a less pronounced loop and would not have crossed the path taken by the salters. The Coln is also a reason why the southerly route towards Quenington would have been ignored, for it would have meant crossing the Coln twice.

However, Coln St Aldwyns is worthy of a stop for those in need of a rest, for it is soon clear why this place has been listed among the ten most desirable residences in twenty-first century England. There has been an inn here since Elizabethan times, although the New Inn was not named such before 1871 when it occupied the site of a former maltster and brewer. It was 'new' in comparison to the Swan Inn, which is mentioned from the early eighteenth century. The Swan doubtless was inspired by the graceful birds which still call the Coln their home.

On the opposite side of the village, past the houses which are emblazoned with the autumnal colours of virginia creepers of vivid reds and golds as the days start to shorten, is the parish church. Its stained glass and architecture are pleasing to the eye, while

its position overlooking the Coln is positively idyllic. John Keble, nineteenth century author of *The Christian Year*, was vicar here as was his father before him.

Leaving the village towards Hatherop, the road almost touches the banks of the River Coln, the point where this meander has edged north over many years and would not have proven a barrier to the earliest pack horses and their masters. Unseen contours in the river bed deflect the flow of the river, making it move faster on one bank than the other. Over time this faster flow erodes the one bank at a greater rate and, at the same time, means the deposition of eroded materials from further upstream is increased on the opposite bank which builds up over time to replenish the land. Within living memory a river can change its course, albeit only a few inches at most, while over centuries the landscape can be changed quite substantially.

It is less than a mile to and through Hatherop, where we reach a junction and turn right to follow a gently arcing lane to reach a junction of four roads. This point will have existed for centuries and would certainly have been seen by those transporting the salt. From this point to the east is Quenington, the road heading directly south along a slope heads to Fairford almost two miles away, and to the southeast runs our Salt Way to Lechlade on Thames.

At this junction is a tumulus, an ancient burial mound which had been so ploughed out even before the word archaeology had been created to make dating it impossible. There is also a milestone, a comparatively recent item but one which would have replaced an earlier marker for this junction is an important one in the landscape, even if this is difficult to see today.

From here we continue along the Salt Way to Lechlade, a gentle road with few obstacles save for two minor fords marked around the halfway point of the four miles to our final destination. Virtually every sign of the route disappears as soon as we enter the town; years of development have wiped the ancient markers from the place. However, there are only two crossing points at Lechlade today and the second is too far east for it to be considered. So enter the town via what was the Salt Way as it becomes Hambridge Lane, at the junction with Oak Street (the A361) turn right and follow it as it becomes Burford Street and then Thames Street.

Thames Street crosses the river at the point known as Ha'penny Bridge, a stone construction of pleasing design and one which tells us of the toll once charged for crossing this point. This would, of course, have been the pre-decimal halfpenny and of which there were 480 to the pound, thus equal to a little over one-fifth of the present penny; a miniscule amount today, but a substantial fee when payable in 1792 when the bridge first opened. The toll house is the curious square building forming one end of the bridge. It replaced the earlier ferry here and was built with an arch 15½ feet above the level of the river to allow the passage of Thames sailing barges without having to go to the trouble of lowering their masts.

Lechlade on Thames is still a major place on the river, for it marks the highest navigable point for the majority of powered craft. It also marks the end of this particular journey, for no Droitwich salt containers have been discovered south of here.

So why travel to the Thames? This question will be answered in the next chapter, when we reach this destination by the alternative route from Toddington, as mentioned earlier.

4

TODDINGTON TO LECHLADE

As mentioned in the preceding chapter, there is an alternative route from Toddington to Lechlade to join the Thames. These routes may not have been contemporary, simply alternative routes to the same point. However, if they were taken at the same time it would have been to disperse the salt to different regions, albeit these were small settlements and the amount of salt minimal.

This route heads further to the east and so we shall pick this up from the Toddington station on the Gloucestershire and Warwickhire Railway. Taking the B4077 east, less than a mile to Stanway, where we find three sites of historical interest. Stanway House is a Jacobean manor house, the estate owned by Tewkesbury Abbey for eight centuries and then five hundred years by the Tracy family. The Tracys and descendants Earls of Wemyss and Lord and Lady Neidpath claim descent from Charlemagne, King of the Franks and the first Holy Roman Emperor, whose conquests and rule resulted in the defining of much of Europe as we know it today. This line is notable for having owned land hereabouts since before the Norman Conquest.

Stanway's gardens are a delight, in particular the eighteenth century water garden, one of the finest in England, which was the work of Charles Bridgeman. It features a formal canal, a stunning cascade, a pyramid, eight ponds and a single-jet fountain which soars to a height of 300 feet – the highest fountain in Britain and powered by gravity, making this the highest in the world to work this way. The church of St Peter has evidence of several stages of building. The lower tower dates from the thirteenth century, the upper part with its gargoyles and battlements from the fifteenth century with the font and stained glass windows nineteenth century.

The route continues to follow this road as it bends to the right and heads south, following a winding path through woodland with names such as the Slade, Oldhill Wood, Squirrel Wood, Congreve Wood, Newhill Wood, and Coscombe Grove, climbing to reach the 800 feet high junction of the roads at Stumps Cross. Today there is a

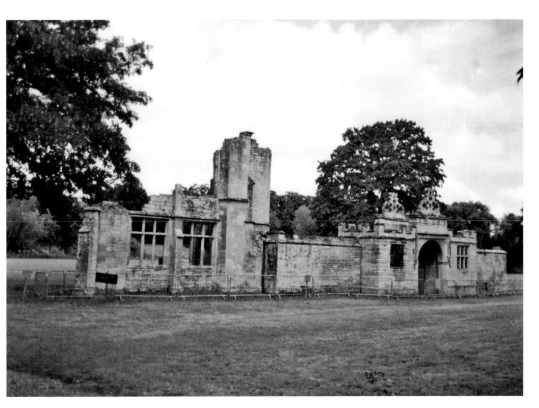

The now ruined outbuildings of Toddington Manor.

milestone here, while the name shows there was an earlier marker for this point to guide travellers and possibly including those who brought the salt from Droitwich.

Here the road turns to a little to the left and heads southwest for a straight mile. From an initial rise, the land passes a quarry to the left before dropping away towards the tiny hamlet of Ford. No surprises to discover the beginnings of the River Windrush in the valley; however, just before entering Ford itself, we take the road to the right towards Temple Guiting, another mile of road follows as straight a course as possible without straying too much from the contour line.

The village of Temple Guiting lies to the east of our route but features a splendid, some say the finest, example of a fifteenth century Cotswold Tudor Manor House. It has certainly been restored to an excellent condition and features all modern conveniences, for it is now available for hire as self-catering accommodation. However, there is no temple here; the church is a small but pleasant twelfth century construction dedicated to St Mary. This prefix refers to this having been held by the Knights Templar, the most famous of the western Christian military orders which flourished during the twelfth and thirteenth centuries. Loyal to the Papacy, their order has been the subject of much speculation and intrigue, their wealth and power meant they were mistrusted and even feared by the established leaders, of both the church and politically.

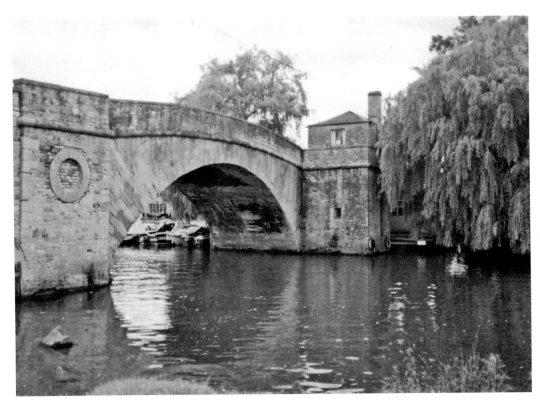

Toll House on Ha'penny Bridge, Lechlade.

The salt route heads on south, following a line above the Windrush to Kineton and potential refreshment at the Halfway House, so-called because this public house lies equidistant between Temple Guiting and Guiting Power, a place which we shall be skirting soon. Our route, and that of the salters, continues above the banks of the Windrush south through Barton towards Guiting Power. The road passes west of the second of the Guitings, this one named after the le Poer family who once held this manor, the larger of the two places to take their name from an old river name meaning 'the strong-flowing one'.

Ignoring the road to Guiting Power, continue south, then after just over a half a mile take the second on the left which brings us along a straight lane to the crossroads at the B4068. Here is the site of an ancient tumulus, and opposite Church Farm. Cross over and continue on to come to the hamlet of Aylworth. There is little to modern Aylworth and even less of the earlier medieval settlement which occupied the site just to the south and where evidence of its buildings can still be seen in the landscape. Follow the road in its loop around and from Aylworth, over the dismantled railway and to cross the A436 where another tumulus lies in the field to the right, hardly noticeable today for it is almost ploughed out.

A few hundred yards on, take the right turn and pass to the north of Notgrove until the T-junction where we turn left and pass west of the village which has been here since at

least the eighth century and tells us it was 'the wet grove'. The church of St Bartholomew is Norman and is thought to have replaced an earlier place of Saxons burials. The church contains monuments to the memory of those descended from the merchant Sir Richard Whittington, whose story was greatly embellished to become the pantomime *Dick Whittington* and yet really did serve three terms as Lord Mayor of London.

It is over a mile south of Notgrove to Turkdean and a further mile until this lane reaches the A429, formerly the Roman road known as the Fosse Way and which would have seen salt transported along the route as a track well before it had received the Roman touch. Indeed, it may have seen salt even before the founding of Rome in 753 BC. On this particular route, it seems they would likely have crossed what became the Fosse Way at this point. However, the Roman road has dominated the landscape here for so long it has changed the layout of the roads and we are forced to take the Fosse Way for a while.

Thus turn right and head south, crossing the roundabout with the A40, before turning left into Northleach. Here is a Museum of Mechanical Music, the route passes the door and is well worth a stop. Inside are many more examples of mechanically produced music than any one person could possibly think of, while the museum also houses a number of timepieces.

Just before emerging from the small town take the right turn signed towards Eastington and Aldsworth, the latter a distance of some four miles. This lane follows a direct course, except where the contours make this impractical. Here the lane parallels the route taken in the previous chapter, averaging just over a mile away.

Along the lane we cross the Diamond Way, a long distance footpath covering a circular route of about 60 miles passing through some of the loveliest villages in the Cotswolds and created to link together the quieter locations. It is so-called because it was created by the Ramblers Association to mark the 60th or Diamond Anniversary of the creation of the RA.

Passing the place names of Upper End, Middle End and Lower End, we descend towards the dog leg in the lane near Eastington, after which the landscape continues to fall away more steeply as we reach Larkethill Wood. Emerging from the wood, with Aldsworth now visible directly ahead of us, the road to the left leads to Lodge Park, a National Trust property which is being restored to its early nineteenth century condition. However, the estate was created 250 years earlier than this as a grandstand for observers to watch deer coursing, while there is evidence of much earlier habitation in the form of a long barrow north of the lodge itself.

Along the straightest of lanes is Aldsworth, a village where most of the buildings have changed little in 300 years, although the church is Norman. This was once home to Robert Garne who is said to have been the owner of the last flock of Cotswold Lion, that sheep breed that once covered the Cotswolds and which formed the basis for the region's prosperity.

Here the Sherbourne Arms offers the weary welcome refreshment, yet reaching this part of Aldsworth means we are heading in the wrong direction. Through the village we reach the B4425, turn right along here and then shortly after the New Cottages on the right take the lane on the left signposted to Coln St Aldwyns.

This lane heads south and within a few hundred yards crosses the young River Leach, the river which gave its name to our ultimate destination of Lechlade. This road runs for three miles to the village we met in the previous chapter on the route between Toddington and here. Indeed, the first road we meet along this lane is that Salt Way which brought us to Coln St Aldwyns in the previous chapter.

As stated earlier, there is no suggestion that these routes were contemporary, although as there are no longer many surviving examples of salt names on this alternative, it could be thought that this alternative was either abandoned earlier or at least was little used by comparison.

There are two routes to Lechlade and, with the evidence of this being used for many years, clearly one of some importance. The question remains as to why come to Lechlade and also why are there so few signs of Droitwich salt coming any further south?

Taking the second question first gives a clue as to what happened to the precious commodity which had travelled this far on pack animals from Droitwich. That little evidence is found south of the river indicates the river was not a barrier, in which case there would have been no Droitwich salt found south of here, but that the salt was taken away downstream on the river.

With no evidence of Droitwich salt along the banks of the Thames, there can have been only one destination for the salt – the capital city of London. Furthermore, the recipient is named on every document associated with the dispersal of Droitwich salt, or more correctly the office of the recipient, the reigning monarch. The king (or queen) was entitled to a half share of the Droitwich salt, the taxation levied by the Crown on the works may seem a little high at fifty per cent but the rate had been set in antiquity and there was no chance of changing it. However, it does give some idea of the vast volume of salt traffic which must have travelled these roads to Lechlade over centuries.

Just what gross tonnage of calcium carbonate and how many packhorse loads this totalled over the years is unknown but must have been an immense volume. Indeed, if the value to the monarchy is expressed by this compound alone its worth to the ruler of England would have been unsurpassed by anything.

5

THE SALT KING

Any examination of the history of salt in Britain has to cover something of the individuals. Selecting one person to represent all aspects is impossible; yet finding one who has more influence than any other is easy. In truth, his life is also well documented and thus it is easier to associate him with the salt workings than anyone else. So this is the story of John Corbett, forever known as the Salt King.

Born in Brierley Hill in 1817, his exact date of birth is not recorded; however, we do know he was baptised on 29 June that year. As infant mortality rates were so high at the time, it was normal for children to be formally entered into the church within a couple of days of their birth and so we can assume this to be very close to his birth. At the age of eleven, John left school and went to work for his father who had his own canal boat business. Twelve years later, John was serving an apprenticeship at an engineering company in Stourbridge, but was soon back working as his father's partner in the family business.

By the middle of the nineteenth century, Droitwich salt production was in need of a boost. The many companies operating here were inefficient, the brine being extracted was contaminated by fresh water, and competition from other sources was threatening to send the businesses to the wall. Luckily for Droitwich, John Corbett had just received his half share following the sale of the family business and was on the look-out for investment opportunities.

The land at Stoke Prior was up for sale by the liquidators of the British Alkali Company. John Corbett, seeing the potential, had invested some of his wealth in this site to the tune of just over £1,000. This equates to about £43,000 today.

In 1854, Corbett had built his salt works on six acres of land at Stoke Prior and was well ahead with his plans to revolutionise production methods. In truth, his new plant led to the downfall of the business in Droitwich, yet this released the workforce to relocate to the new works at Stoke Prior. Furthermore, Corbett had taken giant

Chateau Impney, home to John Corbett.

steps to improve working conditions, provide excellent housing, set new standards for education, and even saw to the social welfare of the workers in the form of a working men's club and ensured their spiritual and physical well-being by employing a chaplain and a trained medical person.

Corbett's background with the canal network saw him utilise this mode of transport to the full. Compared to road transport, canal boats could carry a much greater tonnage at effectively the same average speed. However, the coming of the railways, which ironically almost always followed a similar line much as they still do today, quickly saw the demise of the canal system.

In 1842, the Worcester to Droitwich branch line had a siding leading to the salt works. The wagons were shunted around the yard by horses, coal and other supplies were brought in and salt taken out. When salt production at Stoke Prior was at its peak there were six fully laden freight trains leaving every single working day. Canal boats had limitations, they required space at the quayside, were difficult to manoeuvre and particularly turn, and during the winter frozen canals brought traffic to a standstill.

Grave of John Corbett, at Stoke Prior.

Meanwhile, the railways were faster, ran in all but the worst snowfalls – and there is not one record of problems with leaves on the track in autumn.

Yet despite the obvious advantages by rail, the canal remained in use right up to 1941 when the company's own boat named *Victory* was destroyed, caught in a bombing raid on Birmingham. Ironically, by this time the railway freight was on the decline; lorries may not have carried so much but they brought the goods directly to the customer, so he no longer had to collect it from the nearest railway yard.

With his new business in full swing and production at maximum he became restless once more, and John was on his travels again. It was on a trip to Paris in 1855 that he met Anna O'Meara, who was Mrs Corbett the following year and residing at Stoke Grange – the present Avoncroft College. Nothing much happened until 1868, when he made his first ill-fated attempt to enter politics, losing to rival John Pakington of Westwood Park.

Unable to defeat the man at the polls, John Corbett turned his attention to his home. He bought the manor of Impney overlooking Droitwich and engaged French architect Auguste Tronquois to design a memorable home. In 1874, Corbett stood for election again, this time the Liberal candidate winning twice the number of votes of the Conservative Pakington and the following year Chateau Impney was completed and was overlooking Droitwich from its present position. Their home had cost them a cool £200,000, a positive fortune in the late nineteenth century; although it did nothing

to help their marriage and they had separated by 1884. His working career also took a downturn at this time, productivity fell and poor worker relations saw a series of strikes. Not that he could hide behind any political successes; if he did bring about any legislative changes they were done anonymously and there is no record of any speech in or out of the House of Commons.

This was Victorian England and, as the Victorians were still convinced salt water was a cure for several ailments, he turned his attention to wiping away the image of industrial Droitwich and selling the place as a spa town. The Raven Hotel was bought and renovated, reopening in 1887. The brine baths and nearby hotel were opened as the spa, while the Elephant & Castle Hotel was opened to house the influx of visitors who arrived at Droitwich railway station – another of Corbett's projects. The second brine baths of St Andrews opened shortly afterwards and thereafter Corbett built Salters Hall in Droitwich (which was to become the library), the Almshouses in Wychbold and, in his native Stourbridge, the hospital bearing his name.

These acts saw a revival in his popularity and an increase in productivity at the Stoke Works. To cope with the 200,000 tons of salt being produced annually Corbett had two railway tracks laid down to take the 400 railway wagons showing his name and which transported the salt not carried by one of the 50 narrow boats he had also funded. Still Corbett had not finished and he turned back to the railway. In 1898, renovation was completed and visitors arrived to find themselves confronted by the statues of a dozen Roman gods and emperors, a flashback to the days when the Empire were masters of Salinae – the Roman name for Droitwich. By now, John Corbett owned approximately half of the land on which Droitwich stood.

The town was in mourning following the death of John Corbett, Droitwich Salt King, on 22 April 1901. During the period following his death until the day after his funeral, all flags in his adopted home town were flown at half mast. John Corbett was buried at St Michael's Church at Stoke Prior, to be joined five years later by his brother Thomas, who was buried alongside him.

6

EAST FROM THE TRENT VALLEY

Salters would have used the natural highways available to them. Rivers had carved a route through the country and, as settlements developed alongside these waterways, the villages made natural stopping places. From Cheshire it is easy to see how the River Dove and then the River Trent would have been used to carry the salt, although the upper reaches of the former are too turbulent to risk losing the cargo. Clearly the greatest risk when transporting salt is seeing your valuable cargo dissolving in front of your eyes.

Downstream along the Dove and then upstream we come to Walton-on-Trent, the first of at least two stops in a network of trails which serve the towns and villages east of here, the second being Alrewas (pronounced as to rhyme with 'walrus') where we shall focus our attention. Having landed the salt the routes fan out, serving everywhere in a sweep from Tamworth in South Staffordshire to Ashby-de-la-Zouch in Leicestershire and undoubtedly well beyond.

Landing the salt at Alrewas, the traders made their way along what is now the A513 and undoubtedly utilised the modern A38, previously the Roman road of Ryknild Street, and a highway which undoubtedly pre-dated the arrival of the Romans. Crossing the old Roman road we travel one and a half miles to the first modern reminder of a salters' route. As we come to the River Tame we arrive at Chetwynd Bridge as it is known today. However, in earlier times it was referred to as Salter's Bridge, still shown as the alternative name on Ordnance Survey maps. Today it is difficult to see how this point was crossed other than by boat or the later bridge, as the water depth and strength of the current would make crossing in summer a difficult proposition, while in spate the flood plain here is extensive. This is not surprising considering it is a few metres before the Tame meets the Trent and the Mease.

Today there is no choice to cross the bridge with Croxall Lakes on the left and then pass under the bridge carrying the railway towards Tamworth. Here the road bends

Is this where the salters landed after their journey up river to Walton-upon-Trent?

sharply to the right, while we take what is effectively a left turn to cross a second, much smaller bridge over the River Mease and then turning right towards Croxall. To the right we see what appears to be a well kept country house of impressive size. Yet this is misleading, for the property was built towards the end of the twentieth century, although the much earlier style has been copied so accurately that directors and producers have used the place as a backdrop for several period dramas.

Coming up the gentle incline of Croxall Road, where the road peaks at a bend before sloping down into the village of Edingale, is a distance of almost two miles from Salter's Bridge. Today the name of the village is pronounced as if the word was spelt Eddingale (as in 'bed'), when historically this village got its name from a man called Aeda's and thus should be pronounced Eedingale (as in 'bead') as the modern spelling suggests. Why or when this occurred is obscure; however, it has resulted in strangers reading the name correctly, while the locals have become used to saying it wrongly.

The salt route splits here and first we shall be following the southern road, so pass through the village and climb the hill to the Black Horse, where you may be able to hear the sounds of the gun club in Raddle Lane. Just past the pub take the road on the right leading to Harlaston. About 350 metres after the turning at the mini-roundabout the road bends sharply to the right, while ahead of us is the dirt track marked as Mill Lane. This is where the salt route splits again; the road still takes us to Harlaston, while

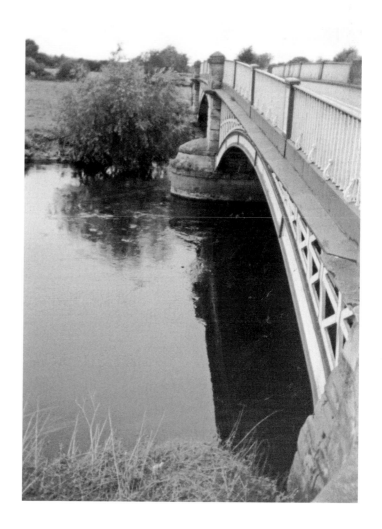

The Salter's Bridge over the Tame near Alrewas.

ahead of us is the public footpath and following this brings us past the old water mill and the footbridges across the River Mease, to rejoin the road east of the main body of Harlaston.

First we shall continue along the road to bring us into the village and to the church of St Matthews on its highest point which is still its geographical centre. From here continue heading south, down the other side of the hill. As we exit the village the road on the right would have been taken to reach Elford. As the name suggests there was once a ford here, indeed it would have crossed the Tame towards the rear of the church of St Peter's. This raises the obvious question as to why the salt was not brought along the Tame instead of overland. While this was a possibility, it seems an unlikely one for this would also have been used to bring salt to Tamworth and there is no documentation to support this within the long and detailed records of that important town.

Elford has not grown much in the twenty-first century; indeed, there is every reason to suspect that as a farming community there were more people here two to three centuries

The River Mease between
Edingale and Harlaston.

ago. This is true of Harlaston where the 1801 census shows a greater population than that recorded in 2001. Elford Hall, which once stood alongside the church, is no more but is remembered by the names of the roads which now occupy the same region, reminders of the gardens, buildings and occupants. The church is said to have been visited by both Henry VII and even Robin Hood, yet the most prominent figures are the Stanleys, residents of Elford Hall and in particular the young John Stanley. Nothing is known of the young man except for his death, somewhere around 1460, for the image in the church shows him holding a tennis ball in the left hand and pointing to his temple with the right, the spot where the ball hit and killed him as he was playing. For some it may come as a surprise to find tennis being played so long ago.

Back at Harlaston the road heading out towards Tamworth stops being Main Road and becomes Portway Lane, not a direct reference to salt but to a market or trading route for the Old English word *port* which was originally used to describe a 'market'. The road is mainly straight and, for the most part, gently undulating and offers good

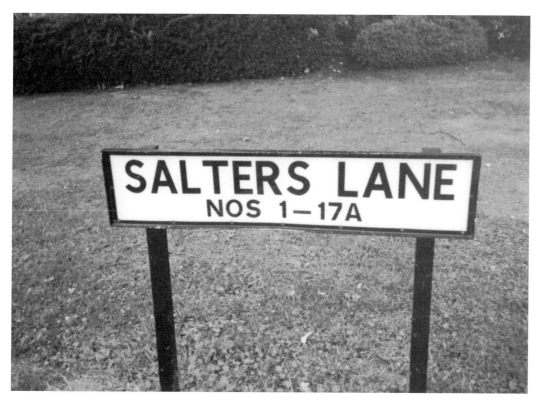

The remnant of the old route for the salt traders to Tamworth.

views of the Staffordshire countryside as we travel the three miles to our next village. Few signs of habitation interrupt us as we pass under the shade of overhanging trees, cross the Trent Valley railway line between Burton on Trent and Tamworth, and descend the slopes of Hanging Hill when the next village of Wigginton is in view beyond the trees and in particular the top of the church dedicated to St Leonard.

Pass the church and the pub called the Old Crown, the only place to spend currency in Wiggington for the telephone kiosk does not take coins and there are no other retail outlets here, and after a negotiating a depression in the road we are soon entering the outskirts of Tamworth. The road is mainly straight, passing through Gillway and its post-war housing estate and cemetery. This road ends in a junction where traffic is forced left; this is a part of a fork in the old road heading north to Nottingham from Tamworth and is still remembered as Fountain Junction by older residents. The name comes from the fountain which stood here from Victorian times and was used to water horses. The water supply had long run dry when the fountain itself was removed after having been hit several times by motorists.

Downhill from this junction we are travelling parallel to the original route, one which we will shortly encounter on the right just before yet another crossing of the Trent Valley railway line, recently widened to form four tracks rather than the original two which had been here since the line was first completed in 1847. The road on the right here is

still known as Salters Lane, which would have taken the salters directly into the centre of the town and to that part of town still known as Market Street. Tamworth Museum, which occupies the upper floor of Tamworth Castle, displays records of traders and their wares (including salt) being sold in Tamworth's market over the history of the town.

That part of the market which was undercover was beneath the Town Hall. This building was paid for by Thomas Guy, benefactor to the town who also left the alms houses and who is known nationally for his founding of Guys Hospital in London. The town hall is also remembered for former prime minister and Tamworth MP Sir Robert Peel, whose statue stands in front of the building and who is remembered for founding the police force or Peelers as they were then known. It was here from an upper window of the town hall building that Peel delivered his election promises, thus unwittingly delivering the first election manifesto.

There is also an arm of this salt route heading east which can be followed by turning left from Harlaston's old mill. We are going to follow this road as it wanders along the valley of the River Mease through the tiny picturesque village of Haunton and on towards Clifton Campville. While the church of St Michael and St Joseph at Haunton is of modest proportions, soon after leaving the village the steeple of St Andrew's at Clifton Campville is easy to see in the distance. This spire, supported by its flying buttresses, soars to 189 feet and is the highest village parish church spire in Staffordshire. It would not have been visible to the earliest salters, for the church dates from the thirteenth century.

In recent years, a priest's retreat has been identified in the tower here. For many years used as a storeroom, its significance was realised when an architect spotted the outlet for the privy. Built into the wall, it looks for all the world like a narrow fireplace from within. However, from outside the brickwork is riddled with holes, effectively a stone grille which allowed matter to flow from the room and across the drainage of the roof on the main body of the church, where it was flushed by rainwater.

Through Clifton Campville the land slopes gently up, this part of the route has been labelled Salt Street on maps for many years, until it reaches No Man's Heath around five miles from Harlaston. This unusual name is derived from it being common land shared by the counties of Staffordshire, Leicestershire, Warwickshire and Derbyshire which historically meet at this point. Until recently the pub here was the Four Counties, reflecting its position where the four ancient administrative regions met. Tradition has it that the exact point was within the pub itself and should the long arm of the law reach out in the bar to capture a miscreant, he had only to retire to another room at the rear in order to escape. While this is a nice idea, that is all it is, for by the time the pub was open for business the officer of the law would have had equal powers no matter what county he was in.

From No Man's Heath follow the road signposted to Austrey, but ignore the bend to the right and follow Salt Street southeast, following the line of the track up two hills towards the wireless station which cannot be missed on the horizon just a mile away. Halfway between these two points a bridge takes us over the M42, a sight which would certainly have terrified the salters of yesteryear who would have travelled less distance in a week than the articulated juggernauts below travel in a single hour.

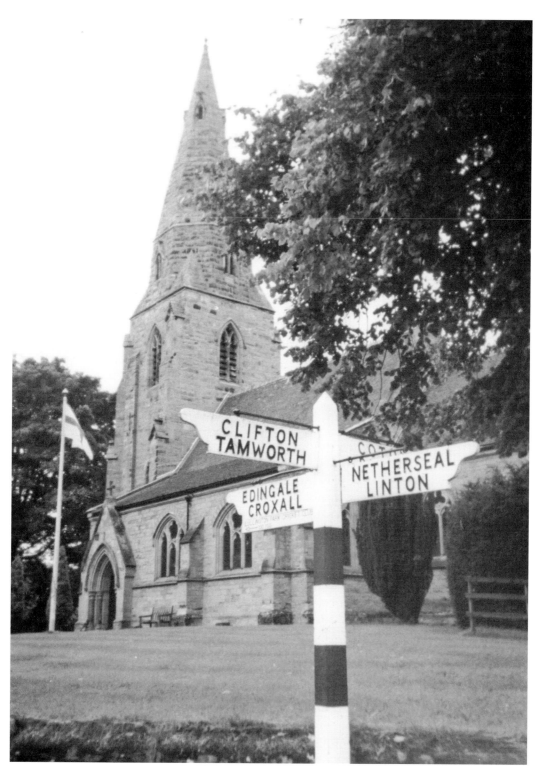

All Saints church, Lullington, has changed little since the later salters' days.

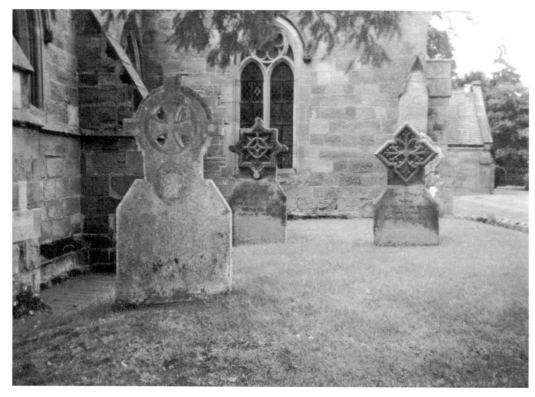

The plot of the Gresley family at Netherseal church.

Descending the other side of Appleby Hill we are now on Red House Lane, a modern name for what was also known as Salt Street, until reaching the busy A444 or Atherstone Road two miles from No Man's Heath. Turn right here and we soon pass by Twycross Zoo and, two miles along, the village of Twycross itself. Here, for those who require such, the Curzon Arms offers both a hearty menu and liquid refreshment. The name reminds us of the family who held land in this manor and who were to become the Lords Howe.

Continuing on through the village there is an obvious fork in the road. While the main road swings left, we shall take the traditional right-hand fork along what is now designated the B4116 towards Sheepy Magna some three miles away and eventually Atherstone another three miles further on. For those who missed refreshment at Twycross there are opportunities at the Black Horse in Sheepy Magna and the Red Lion at Pinwall, although the choice at the town of Atherstone is much greater.

It is interesting to note that Tamworth and Atherstone, long established towns connected by the Roman road of Watling Street and now the A5, have no record of salt being transported, sold or traded along the obvious route. This could be suggested as evidence that the ancient salters were distributing their products from Cheshire around this region well before the arrival of the Romans and the existence of the Roman road. It does show there was no salt coming along that road and that the distribution continued along traditional routes.

While the distribution undoubtedly continued further to the south of both Tamworth and Atherstone, it seems the salters would have used these popular market towns to distribute out from here. This would certainly have been a popular suggestion for a number of merchants who would have made a healthy profit on any salt they acquired here. Hence we shall return to Edingale and follow the more northerly arm of this distribution network into other parts of Leicestershire.

Return to where we left Edingale at the mini-roundabout and went off towards Harlaston, the road heading very straight on up the gentle slope to reach Lullington two miles away, when we are now in Derbyshire. The most striking feature here is the village green and its backdrop of All Saints church with its oddly squashed conical spire. From here the road detours from what was the earlier route, taking a more northerly loop around to graze Grange Wood before heading into Netherseal. However, there is a public footpath offering a more direct journey, emerging opposite Clifton Lane and running straight into Netherseal two miles away. On the cross country journey we cross Seal Brook, undoubtedly named by the process of back-formation from the villages of Netherseal and the larger Overseal.

Netherseal features a church dedicated to St Peter and a pub called the Holly Bush. Netherseal is the final resting place of Sir Nigel Gresley, the famous steam locomotive engineer who built both number 4472 the *Flying Scotsman* and number 4468 *Mallard* which still holds the record for the fastest speed ever attained by a steam locomotive, 125.88 mph. The village's second claim to fame is as containing the southernmost point in the county of Derbyshire; however, Lullington appears to extend to an equal latitude today.

From Netherseal, take the road to Acresford where we momentarily meet the A444 we left at Twycross earlier. Turning right here and then quickly left, we follow the road which splits in two; the road ahead goes to Measham and the right hand turn towards Donisthorpe. Briefly the road to Measham, which soon disappears beneath the concrete of the modern town within a little over a mile, passes three places named for this salt route: Saltersford Cottages and Saltersford Farm on the right, before Saltersford Bridge which (as the name suggests) replaced the earlier ford used by salters.

The other route heads into Donisthorpe, approximately a mile from the A444. No evidence of the salt route remains; indeed, the route through Donisthorpe is very urban in comparison with the rest of this leg of the journey. We are treated to little more glimpses of England's green and pleasant land as we head on following the road to Ashby-de-la-Zouch. This is a journey of approximately four miles; the last mile or so passing through the southern housing estates of this market town.

As with Tamworth and Atherstone, the salters undoubtedly used the merchants of this market town to distribute their wares. For those visiting in the run up to Christmas, they will find the High Street closed to traffic and, impressively bedecked in Christmas lights which are visible when approaching from the northern uplands, home to a Christmas market and fair. Ashby is best known for its castle, founded by Alain de Parrhoet la Zouch in the twelfth century. Today this is a ruin, as a result of it being taken by the Parliamentarians in 1646 having been a Royalist stronghold. Prior to this, the place had been visited by Henry VII, Mary Queen of Scots, James I and Charles I. Folklore speaks

of it being associated with Ivanhoe, yet Sir Walter was a fictional character created by Sir Walter Scott, who set the opening jousting tournament scene at this castle.

Unlike other salt routes covered in these pages, this is not a single long route but shows how a network of routes developed over a period of time. Not every journey would require the same stopping points or the same goals and thus salters built up a map of potential clients and contacts in a particular area. This region to the east of the Trent may be geographically closer to Droitwich, the other major inland source of salt in England, but that town had commitments to the south and southeast.

Cheshire salt is unlikely to have been transported much further east than this in Leicestershire, supplies could just as easily have been brought in the opposite direction from the Wash, for sea salt was an inexhaustible source and much easier to obtain. Further east and Lincolnshire has been known to have Cheshire salt rights; however, this would have political rather than functional.

7

NANTWICH TO DERBY

Salt from Nantwich was extracted from Roman times. Documentary evidence exists from the Roman era when salt was transported to the garrisons at Chester and what is now Stoke-on-Trent. Domesday records eight salt houses in the town in 1085, when the manor was under the control of William Malbank.

The eleventh century census also records a salt-pit which continued to produce salt until as recently as 1856. Production continued even during the aftermath of the fire which raged for twenty days in 1583 when the town was almost entirely rebuilt, with the financial backing of Queen Elizabeth I. Several of the black and white Tudor buildings from this time are still standing. Over the years, the salt has been used in the production of Cheshire Cheese and in the tanning of leather. Textiles companies continue to be among the largest employers in the region.

To the west of Nantwich, almost on the left bank of the River Weaver, is a reminder of the days when salt was produced in great quantities. Here is the recent housing development known as Salt Meadows, which is fittingly to be the starting point for this particular journey which still falls along much the same path as it has for centuries, at least as far as the first leg to Newcastle-under-Lyme. However, this does mean that the modern road surfacing and construction has erased much of the evidence in the landscape.

Heading northeast through the estate we reach Welsh Row, now designated the A534, and turn left towards Nantwich town centre. As with most towns the modern A-road by-passes the town centre as we head east and, unless there is a desire to visit the museum in Pillory Street, it makes sense to follow this route as it is so well marked. Welsh Row turns right into the delightfully named Water Lode, then Station Road, Pratchitts Row and right on to Hospital Street, before reaching the traffic island where this becomes London Road and is designated the A51.

After two miles from our starting point we come to the large island where the modern signs will direct us along the busy dual carriageway, while we join the island and take

The village stocks at Caverswall.

the fourth exit along the Newcastle Road. This road winds through gentle rolling countryside, passing through Blakelow, Shavington, and Hough before crossing the railway line between the important railway towns of Stafford and Crewe and coming to the A531 north of Chorlton, a distance of almost three miles after leaving the traffic behind at the junction with the A500.

The busier traffic lanes here are soon behind us, for as soon as we have crossed one island and travelled just under a mile, we come to the left turn along the B5500 or Four Lanes End. This takes a fairly straight line east through Balterley and, a mile along, cross the six lanes of the M6 motorway. Here there is a sharp right turn along Limbrick Road and the first sign of the Lyme Forest which gave its name to both the road and to Newcastle-under-Lyme. However, this does not refer to lime trees but to elms, while Limbrick is a minor place name referring to 'the elm ridge'. At first running parallel to the motorway, it then swings away and soon becomes Shraley Brook Road. By the time the road name changes again, this time to High Street, we are into Halmer End.

Unfortunately this village is best known for an incident which occurred on 12 January 1918, when a huge explosion rocked the village. Over 1,000 feet below ground were several very profitable coal seams of the North Staffordshire Coalfield and the Minnie Pit worked the coal faces here. The explosion resulted in the deaths of

Dilhorne's church of All Saints, with its highly unusual octagonal Norman Tower.

156 men and boys, the youngsters being in the mine because of the shortage of men owing to the number fighting for king and country in the Great War. Even though it was a profitable venture the mine never recovered and closed for good twelve years afterwards. A memorial in the village commemorates the lives that were lost on that fateful night.

High Street then becomes High Lane in under half a mile and we enter Alsagers Bank. The road changes name yet again as soon as that village is left behind and we are now on Blackbank Road, which runs for a mile into Knutton when the road is again known as High Street and straight afterwards it is Knutton Lane. This is the B5367, which takes us into the conurbation that is Newcastle-under-Lyme and the towns of the Potteries. Modern developments have wiped all signs of the ancient salt route from this developed area. Documents show there were salt houses and routes through this region. Yet as we are going to find it impossible to trace the road, we shall simply follow the A52, A5006 and A5007 to Longton.

Having crossed the railway line in Longton we come to Market Street, and turn left down Anchor Road and immediately right along Sutherland Road. Another 200 yards along and Weston Coyney Road leads us off to the left. Follow this to the junction and turn left on the A520 Weston Road, then right on to Caverswall Road and we are soon out of the town once more.

Come down through Cookshill and then along School Lane into Caverswall proper, where we continue along roads called The Dams and then right along the Square. Just south of here is Caverswall Castle, a building which began as a country house in the thirteenth century, fortified in 1615 and was extensively refitted and refurbished in 1890. However, the route turns off before this along a road known as The Hollow. This is a name found in many places and almost always referring to a road which has been literally 'hollowed out' due to the constant passage of carts.

At the end turn right and follow Dilhorne Lane for just under a mile until it becomes Caverswall Road again, where we shall pause to look down and reflect on the preserved standard gauge Foxfield Light Railway. Built in 1893 to serve the Dilhorne Colliery and connect it to the main line at Blythe Bridge, it ceased running in 1965 when the colliery closed. This 1 in 25 gradient is one of the steepest on any perseveration railway, making the engine work hard and providing excellent photo opportunities for enthusiasts as clouds of smoke and steam billow from the locomotive.

Half a mile further on we begin to see the first signs of Dilhorne, a village which no longer benefits from its major industry of coal mining. Indeed, the first pub we come to, previously known as the Colliers Arms, is now Charlie Bassets and is named after a former landlord. It is opposite All Saints Church which is one of the oldest churches in Staffordshire and features a highly unusual and attractive octagonal Norman tower.

From here the Staffordshire Moorlands Walk heads east, part of the footpath taking a more direct route towards Cheadle. However, apart from a tumulus 400 yards east of the church, this alternative is of little historical interest and there is no evidence to suggest this was the original salters' route and thus we shall remain on the road. Turn left at the junction and follow New Road and we soon reach an alternative watering hole which goes by the name of the Royal Oak.

Pump at Great Cubley.

New Road ends in High Street, where we turn right and quickly left along a road called The Common which we follow for three-quarters of a mile to the hamlet of Boundary. This aptly named hamlet lies on the traditional border between Staffordshire and Derbyshire, where a delightful pub awaits in the form of the Red Lion Inn. At the crossroads in the centre of Boundary turn left along Delphouse Road towards Cheadle and not right to take the Cheadle Road which, ironically, leads away from our next destination towards Forsbrook.

Two miles along this road, the A521 passing Brookhouses when the road name changes to The Green, then Town End and High Street, will lead past the cemetery and bring us to the junction with the A522. Turn right here and follow the new A-road, or Tape Street, for 200 yards to and across a traffic island, then a further 70 yards to turn left along the B5032 Ashbourne Road. Within half a mile we are leaving Cheadle and travelling through increasingly hilly country as we near the Churnet Valley and the first noticeable inclines of the southern Pennines.

This road travels east for almost five miles, through Hansley Cross and Gallows Green, entering Alton to the south of the village. Alton is best known for the theme park of Alton Towers, although it also claims to be the most haunted village in

Staffordshire. Two legends of note, the most commonly reported being the man in a top hat who rides around the fields and lanes around Alton and who may be connected with the second tale.

The more dramatic narrative concerns the chained oak, a tree in Alton Woods which is well signposted for those curious enough to want to view it. On an autumnal evening in 1821 the Earl of Shrewsbury, whose residence is now the theme park, was returning home when an old woman appeared in the road ahead of the coach. The crone begged a coin when the coach stopped but was sent packing by the earl, whereupon the woman cursed him declaring that 'For every branch that falls from the tree shall be matched by a death in the earl's family'. The earl paid no heed but later that night a terrible storm broke a branch and that same night a member of his family died. Shocked by this he ordered the chaining up of some branches to ensure the tree dropped no further branches.

There is a second version which suggests there was only one death, again that night when the branch fell from the tree and killed one of the earl's relatives. This may well tie in with the story of the ghostly rider, while there is documented evidence of a fatal riding accident around this time. As the name suggests the oak is still chained today, although in 2007 a branch fell when one of the original chains rusted through. It is not known if this coincided with another tragedy in the family. At Alton Towers there is a ride known as Hex which is based on this story.

As we enter Alton the road name changes to Saltersford Lane, a clear indication of a salters' route. At the junction with Uttoxeter Road and Denstone Lane the salters' route continues ahead; however, this is not accessible by vehicles for far and soon becomes just a footpath. If we do follow it on foot it will rejoin the main road in a little under two miles, a road which we can follow by taking the right turn along Denstone Lane. As this road skirts the village it sweeps left and, here allowing the footpath to rejoin, heads towards the Churnet in the valley. However, we do not quite reach the river but turn left along the B5031 towards the Roman settlement that is Rocester a mile away.

At the junction with the B5030 turn right and then almost instantly right along the Ashbourne Road which takes us into Rocester itself. Here we will be joining the Roman road but cannot leave without looking at this important Roman station which was founded here in AD 69. The earthworks, which undoubtedly pre-date the arrival of the Romans, are still visible today.

The confluence of the rivers Churnet and Dove made this an ideal situation for a water mill; hence why Richard Arkwright purchased an old corn mill in 1781, converting it to a cotton mill and resulting in the arrival of the canal and eventually the railway. The mill is remembered by the name of Mill Street, the road we turn left on to at the island at the end of Ashbourne Road. We are now on the road surfaced by the Romans, although there is every likelihood it existed well before that time.

One mile along here is a crossroads, while we carry straight on and thereafter take the left turn along Cubley Lane, ignoring the road to Marston Montgomery. It is a journey of approximately two miles to Great Cubley, Little Cubley being just south of here. Passing through the village keep an eye open for the village pump, an attractive and well maintained reminder of previous years although this only dates from 1902. The

village was the birthplace of Michael Johnson, who later moved to Lichfield where his son Samuel was born, the man who produced the first true English dictionary.

From the crossroads at Great Cubley, the road now known as Derby Lane, it would be a straight eight miles heading directly east if we were able to follow the course of the Roman road. However, there are a couple of deviations from this straight road, notably that which takes in Alkmonton. While the Roman road is still marked on the map, it is not possible to follow it across country for this is now private land.

After a mile the road turns off the Roman line and meets Leapley Lane where we turn right and enter the tiny hamlet of Alkmonton. Quickly take the road on the left before reaching St John's church, travelling along Long Lane as it loops around to rejoin the path of the Roman road albeit only briefly. Long Lane then takes a southerly detour near Longford where it crosses a tributary of the River Dove and its church of St Chad's, a place where a famous rector served from 1850 to 1899.

General Sir George Anson commanded the British cavalry under the Duke of Wellington, also serving as a member of parliament; however, it was his seventh son who came to Longford for a period of almost half a century. Yet Thomas Anchitel Anson had already achieved fame as a cricketer, representing Cambridge University from 1839-42 and the MCC from 1839-45. His statistics would hardly raise an eyebrow today for, in 44 first class matches as a batsman, he only amassed 872 runs, with a top score of 72 and an average of just under 13 – however, these were times when runs were much harder to come by.

Thurvaston is the next point of reference just two miles away, although it is not a large place and in a vehicle could even be missed. However, it is a further two miles before the road deviates much, that is when Long Lane meets the B5020 or Moor Lane. Turn right here and then first left in 400 yards onto Brun Lane. Another mile on and we reach and turn left on the A52 Ashbourne Road and shortly enter the village of Mackworth and its pub the Mundy Arms, a family which can be linked with Mackworth and Mackeaton since the time of Edward I (1043-66) and also known as Edward the Confessor. Also at Mackworth we find the remains of Mackworth Castle, which seems to have had several periods of construction, beginning in the fourteenth and fifteenth centuries.

From here the A52 takes us directly into the centre of the city of Derby just over two miles away. It is tempting to suggest that the goal for the salters was Derby Cathedral and this may well have been the case, that or one of the old gates allowing access to the city, St Mary's Gate, Iron Gate, Sadler Gate or Friar Gate. However, in later years this was probably heading for Cheapside, the Old English *ceap* meaning 'market' and the logical place for the salt to be sold.

It seems unlikely that the salt would have travelled much further, at least not by road, for the River Derwent forms a natural barrier just ahead.

8

DROITWICH TO OLD SODBURY

As with so many other Droitwich routes we start in the town but, for this route we shall begin on the modern Saltway at Vines Park. Looking up we see the church of St Augustines on Dodderhill, and we must turn right here and head up to the crossroads and the traffic lights. Turn right and we are heading towards the city of Worcester, aptly along the Worcester Road. After a mile we arrive at the second traffic island and join the A38, here still very much following the line of the old Roman Road.

This is the start of a journey which will parallel the trunk road which has been used to reach Bristol for longer than written history records. The road and its modern traffic signs will be used several times to point us in the right direction through built-up regions of the larger towns and cities we shall be passing through. This route takes us approximately sixty miles to Old Sodbury via some of the most historic towns in the country.

After a mile and a half we pass Martin Hussingtree where the line of the Roman road continues straight ahead, while the trunk road bears right. Ideally we would wish to follow the ancient route but this is impractical, for it is soon obliterated by two thousand years of construction. However, the trunk road deviates some way off the route and so we will be turning off the A38 at the junction with the A4536, at the point near the former railway station and where the line passes under the road.

Hence we turn left and follow Hurst Lane and, after it crosses the A449, it becomes the Blackpole Road (designated the B4550) and crosses the Worcester and Birmingham Canal. Paralleling the railway through Blackpole, the road brings us to Brickfields road where we turn right and pass beneath the railway and then immediately left at the island and down into the city itself. Following the signs for Tewkesbury brings us quickly to the museum known as the Commandery. Opened thirty years ago, it was the first to be dedicated to the English Civil Wars and is the perfect introduction to the battles which took place around here in the middle of the seventeenth century. It is well worth a visit for we shall soon be passing through the battle sites.

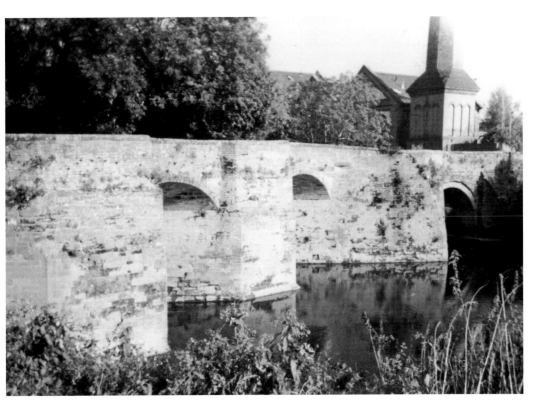

The not so old bridge at Powick, site of the Battle of Powick in 1651.

Alongside the museum is the Birmingham and Worcester Canal once more; indeed, for those travelling on foot this is an alternative route, while for those cruising the canal the locks at the end allow access to the Severn. We have travelled several miles through Worcester and have not seen any sign of salt or a mention of same for some time, other than the canal which we know was used to transport salt but this was almost yesterday in comparison. From here we will shortly be rejoining the Roman road which offers one of four possible routes heading south towards Old Sodbury; the newest and most easterly is the M5, to the west is the River Severn which is certainly the oldest, while between intertwines the lines of the A38 trunk road and the Roman road.

Cross the road and follow the road opposite the Commandery, called Commandery Way, and then the Bath Road (a clue to the destination) and this is the A38, which brings us in two miles to the second of two traffic islands where we follow straight on and then turn left 300 yards along, eventually to Taylors Lane and, another 300 yards along, where we turn right and follow the public footpath which is also the route of the Roman road and, without doubt, we are back on the salt route once more. Indeed, there is a document dated 1426 which seems to suggest this route is 'the king's highway called the Saltway'. Note it is possible to follow the route on the road simply by continuing along the trunk road. Most points of interest can usually be reached via a minor detour.

The footpath takes us south, while to the east is the village of Powick, site of the victory by Prince Rupert in the battle of 1642 and where he was pushed back across the River Teme at Powick Bridge by the Scots infantrymen in 1651. Under our feet we are crossing the point where, on 3 September 1651, Cromwell's New Model Army was camped and began the long sweeping attack on Worcester itself. This fighting force had been created in 1645 and was unique, for this was the first professional army in England; prior to this, fighting men were drawn from the fields by the lords of the manor and assembled along the same chain of command as that used to govern the country. While brave and competent fighters, these were not soldiers and thus were at a great disadvantage when pitched in battle against trained fighting men.

A mile south along the footpath, the route rejoins the tarmac of the modern road system and we find ourselves on Holdings Lane. Ahead are two miles of road which mirror the early Roman and the salt route. At the junction with Brookend Lane turn left and then sharply right to continue along the correct route of Napleton Lane. The salters would certainly have issued salt to Kempsey, perhaps receiving in exchange walnuts which were collected at the south of the village at Bannut Hill. The word is a dialect term for the walnut and here is the furthest north example of its usage, possibly indicating that this village was settled from the south rather than from Worcester.

Kempsey's church contains the ashes and a plaque to Lieutenant-Colonel Sir Richard Carnac Temple, who lived at the Nash (see below) and who is described as a soldier, civil servant, scientist and literary man, whose career rode on the back of the British influence in India. The church was visited by John Whitgift in 1578, when he was instrumental in restoring the bells, bell ropes and fences, and is also credited with curing a leper. Five years later he was Archbishop of Canterbury, being present when Queen Elizabeth I died and crowning her successor, James I.

Napleton Lane is not challenging; hardly any incline can be sensed and yet we are about to find our gentle saunter through the English countryside interrupted by an unavoidable attack on our senses. As we reach Bestman's Lane we are aware of the sound of the traffic from the M5. Take a left and a quick right, leaving the lane along the footpath, which will take us first below the side of the northbound carriageway until we reach the lane where we turn right and then left towards Kerswell Green, where the house called the Nash may be visible to the north depending upon the amount of green on the trees. While the salt route would have followed a line closer to the opposite side of the motorway, there is no point in detouring around the other side, for there are no longer signs of this route as the public footpath only brings us back to this side within a few hundred yards.

Pass Kerswell Green and, ignoring the lane off to the right leading to Severn Stoke, follow the road to arrive at Kinnersley in a little over three miles after leaving the motorway. There is a public footpath leading off which takes the slightly shorter route to Kinnersley, emerging at the Royal Oak, yet there are no signs of a salt route and this simply slows the progress. Here the route depends upon the mode of travel; motor vehicles will need to head towards Severn Stoke and join the A38, while others can continue southeast, passing the village smithy as we exit the hamlet of Kinnersley and 300 yards later leave the road and follow the footpath signposted for Baughton. There

is a lane crossing the path, and it does take a couple of turns, but the route is clearly marked and there are no other paths to take.

We then emerge at Baughton Hall Farm and thereafter the main street through the village. Cross directly over and follow the lane past the housing, at the junction turn left and follow the road all the way to Hill Croome one and a half miles away. While the church may not be a large building it stands on a rise in predominantly flat country and is visible for most of the journey from Baughton. Behind us we can hear the sound of the traffic, not just from the motorway but also the northbound Strensham Services.

On reaching the road from Ryall to Upper Strensham, turn left and then right in 75 yards along the public footpath. Here are two quite unusual place names, the high point to the right is known as Wooshill, while the few trees ahead of us mark the place known as Mogstocking. Continue south along the footpath passing Lee Coppice, and in just over a mile we see further signs of the Roman road. The evidence is in the form of place names Stratford and Stratford Bridge, which feature the Old English element *straet* which is used solely to describe a Roman road. It is also here that we rejoin the A38, which we shall turn left on to and follow to Tewkesbury, a distance of approximately three miles.

To the west of this leg of the route are a couple of places of note. In the village of Ripple is a cross and stocks which have probably replaced an earlier marker cross. The village takes its name from the Ripple Brook, which flows past Towbury Hill south of the village, the site of an early hill fort which must have been one of the original stopping places on this salt route.

Back on the road, nothing much happens until we near the outskirts of Tewkesbury and the region called the Mythe. This term comes from its location between the Rivers Severn and Avon and an excellent description of this wetland. King John's Bridge is stone built relic from the reign of the monarch of the early thirteenth century, of which some of the original brickwork can still be seen on the north side. Cross the two bridges and arrive in Tewkesbury proper, turn right on to High Street and then right again at the traffic island on to Church Street and thus missing out the modern A38 in order to visit a jewel, Tewkesbury Abbey.

The abbey was built by the Normans; it was consecrated on 23 October 1121. It can claim to be the third largest church in England which is not a cathedral (Westminster Abbey and Beverley Minster being larger), while fourteen English cathedrals are of smaller dimensions. Dedicated to the Virgin Mary, it is one of the most striking buildings of its age and greatly impressing the architectural scholar Sir Nikolaus Pevsner.

Follow Church Street around as it follows the line of the Severn, then continue as it becomes Gloucester Road as it swings away from the river and passes the site of the Battle of Tewkesbury, fought in what is now chillingly known as Bloody Meadow on 4 May 1471. The engagement marked the end of the first phase of what was to become known as the War of the Roses and, if you happen to be passing during the second week of July when the Tewkesbury Medieval Festival is on, will see the annual re-enactment of the battle.

A mile after leaving the abbey we arrive at the traffic island, where we rejoin the A38 and turn right to continue south. The next leg of the journey is somewhat blurry,

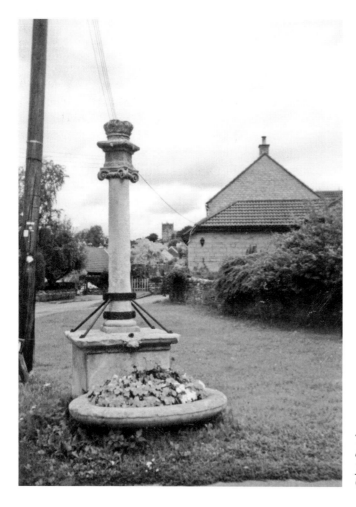

The memorial to commemorate the Diamond Jubilee of Queen Victoria, in Old Sodbury.

markers are virtually non-existent, and is limited to a couple of vague references in a deed dated 1508. Here we learn the route led out of Tewkesbury along the now lost Salters Lane, and thereafter heading to Cheltenham where it passed over Salters Hill to the north of the town and a second Salters Hill just over a mile south of Cheltenham. None of these are known these days, yet the next point of Salterley Grange still exists and so we shall travel the obvious route through Cheltenham and pick up the trail again at that point.

Thus we follow the A38 for three miles to Coombe Hill, where we find the turning left signed for Cheltenham along the A4019. From here it is a five mile trip into the town centre where we pick up the A46 and follow it south heading towards Leckhampton. Indeed, it is the Leckhampton Road which branches off less than a mile south of the town centre; officially designated the B4070 after a mile and a half we leave the buildings of Cheltenham and climbing sharply to what is now marked as Devil's Chimney.

This is an ancient site, home to the outline of a settlement and a tumulus, all of which are clearly visible from aerial photographs. It is tempting to suggest that this was the

Salters Hill south of Cheltenham, especially as the next known marker is just to the south at the base of what is called Leckhampton Hill. Here is Salterley Grange, and shortly afterwards Salterley Oak was marked on earlier maps. These are classic markers on salters' routes, the oak tree considered a permanent marker and, in comparison with the human lifespan, these great trees are. From here continue along the road to the south, arriving at the island carrying the name of the pub here, the Air Balloon.

At this island take the second exit, heading south along the A416, and take the time to absorb the amazing views to the west from this road, for we are now running along the edge of the Cotswold escarpment. A mile along from the Air Balloon there is a road on the right heading towards Birdlip, the road still designated the B4070. By car the route is simply to follow the road all the way into Stroud, a distance of approximately ten miles. On foot the journey is going to be a little more taxing but also more rewarding, for it will follow the route taken by the salters.

Just over a mile after leaving Birdlip the road turns to the left, veering away from the woodland it had previously been hugging. Here is a public footpath continuing along the same line into and alongside Cranham Wood, to emerge and cross the lane to Cranham then follow a line just below the summit for a further mile and reach three markers. The first region on the right is Saltridge Common Wood, while ahead of us with its summit hidden by Saltridge Wood is Saltridge Hill. The footpath takes us through Lord's Wood and leads down the slope towards Sheepscombe. Here, take a good look ahead as the path emerges from the wood, and in front will be seen the church dedicated to St John, a marker which we should head towards, taking any of several routes through the village.

From the church, head southeast and reach the road running below Blackstable Wood and passing through Jack's Green as it becomes Beech Lane, then the left fork at Cockshoot, and at Bulls Cross stay to the right and follow Yorkhouse Lane as it winds its way along to Juniper Hill. At the junction turn left along Wick Street, which largely follows the contour below Wickridge Hill and descends to become Painswick Old Road, and at the junction meets the present Painswick Road, the A46 and the traditional road to Bath. Turn left and follow this to the island where it becomes Beeches Green, and thereafter turns right as Merrywalks, and finally negotiates two further traffic islands to become the Bath Road and head out of Stroud past Rodborough and on through Woodchester to Nailsworth.

As we enter the village we pass Woodchester Roman Villa, a building which was undoubtedly here during the days of the salt route. Indeed, there is reason to believe this would have been an important stop on the journey at that time. Little remains of the villa today and nothing can be seen above ground. The home was occupied from the early second to the late fourth centuries; however, its most famous relic is the so-called Orpheus Mosaic. Uncovered in 1793 by antiquarian Samuel Lysons, it dates to AD 325 and is the second largest mosaic ever found in Europe and also one of the most intricate of designs.

There is no doubt this was an important site for the Romans; it covers 26 acres and has attracted several theories as to its origins. The Cotswolds was one of the most affluent areas in Roman times, and Woodchester was certainly of great importance.

Perhaps it was simply the headquarters for the campaign against the Silures tribe of South Wales; however, this does not explain the grandeur of the place even in its earliest times. More likely it was home to the Roman general Vespasian or to the governor of the province.

It should also be realised that the idea of a single build and occupant is quite misleading. Indeed, it is likely that the place was already the home of the Dubonni tribe before the Romans arrived in England. To use the term 'tribe' today carries an impression of barbaric wild men, when in reality this group were a civilised community who had dominated this region and parts of Worcestershire and Somerset for over five centuries. It is possible that the Dubonni were already trading in the Roman Empire many years before there was any suggestion of a Roman presence in Britain, and they were certainly quick to benefit from the Roman occupation. Indeed, the idea of any 'invasion' today is seen as a minor rebellion and the idea of 'barbarians' is solely based on the written history penned by the Romans.

Two miles further south along the Bath Road, just past the Egypt Mill Hotel, the road splits three ways; the road on the left heads towards Avening and shortly afterwards the road on the right is Old Bristol Road, which leads to Horsley. It is likely that this second turning was also an offshoot of this salt route, for the region north of Horsley is still called Whiteway. The road winds out of the valley and heads south across a comparatively flat region for approximately five miles until we near Leighterton.

The road leading into Leighterton is Whitewater Lane; Whitewater Farm is along here, and yet there is no 'white water' near here and thus this suggests this could be another reference to the salt route. Just east of the village is the Long Barrow; a burial mound is often an indication of an early trackway and especially as it is on the highest point here where it makes an obvious marker on the skyline. Shortly afterwards, we find two further pointers on the A46, less than two miles along from Leighterton. Here we find Whitewell Wood, which might be a reference to a 'white spring or spream' or perhaps the white is a reminder of the salt route, while another tumulus is found here. Nan Tow's Tump is a Bronze Age barrow which dates from around 1500 to 2000 BC, its name coming from the belief that a local witch was buried standing up beneath the 10 feet high round barrow.

Another mile south and we arrive at Starveall where, in the field to the right just before the crossroads, is a very obvious tumulus covered in small trees and shrubs. Within a hundred yards and a little further away from the road is a long barrow, further indicators of the age of this trackway. Another mile and the road passes through the area known as Dunkirk and thereafter Petty France, a name derived from *petite France* or 'little France', and we are now within three miles of the end of the journey.

The modern A46 road deviates somewhat from the straighter path of the earlier salters. Had the road remained on its original course it would have been much closer to the hill fort just south of Little Sodbury. This Iron Age construction is thought to have existed for five centuries before the arrival of the Romans, who also utilised this defensible site, and both cultures would have been recipients for the goods carried by the salt traders. Below the western slopes of the hill are old Pillow Mounds, artificial earth mounds thought to have been deliberately created for the rabbits introduced to

this country by the Normans as a new food source. Little Sodbury proclaims itself a Thankful Village, one of the few places in the country not to have suffered any losses during the Great War of 1914-18.

After this it is but a short step to Old Sodbury, and where trains are heard but not seen as they pass through the tunnel beneath the hill here. This was cut by the great engineer Isambard Kingdom Brunel who, in typical Brunel style, included an ornate ventilation shaft on the hill which resembles the chess piece known as the castle or rook. This is but the first of six spaced out along the tunnel, but the only one which is visible from this perspective. In the centre of the village, opposite the Dog Inn, is a cross, commemorating the Diamond Jubilee of Queen Victoria.

It is likely the trade route continued on to Bath, although no archaeological or documented evidence has been discovered to substantiate this so far.

9

DROITWICH TO LEOMINSTER

Our first route from Droitwich headed east, the others have taken us south; here we shall be taking a route to the west. However, we shall start from the same point of the statue entitled Salt Workers found outside Droitwich Library and Victoria Square.

With the Raven Hotel behind us, head west along Ombersley Street East, bear right on to Colman Road and then immediately left on to Covercroft, and up to the traffic island where we head straight across and follow the Ombersley Way to the next island, turn left and then simply follow this as it sweeps around to cross over the A38. At this junction take the A4133 signposted for Ombersley and Tenbury Wells and then follow the road as it winds through the trees and some delightful rolling countryside.

After three miles we pass beneath the busy A449 and, at the island, head straight over and continue east. Ombersley was granted by charter to Abbot (later Saint) Egwin of Evesham Abbey in AD 706. The remains of the original church of St Andrews, where two stone coffins were found in the early nineteenth century, can still be seen alongside the new version built in 1825. The Kings Head Inn here dates from the fifteenth century and is thought to be where King Charles rested after the Battle of Worcester; the royal coat of arms was marked in the plaster of a downstairs room to mark the event and can still be seen today.

Continue along the A4133 and we come to the scenic views afforded over the Severn at Holt Fleet as we cross the bridge. This is the Holt Fleet Bridge and spans the river courtesy of a single iron arch resting on stone piers and is the result of the Act passed on 5 May 1826. It remains an impressive feat of engineering which is best admired from the river, or the Holt Fleet public house which offers refreshment on the opposite bank over the 150 ft span built by Thomas Telford.

The volume of water here today would make crossing impossible for the salters, other than by boat. However, there is evidence of a crossing point further upstream in the form of an old place name, which also appears on the side of the Lenchford Hotel. Here,

Fording this part of the Severn behind the Lenchford Hotel is not to be recommended today.

as the name suggests, the River Severn was once forded. Crossing it on the day this route was travelled would have been foolhardy and the river was not anywhere near in spate. It is not certain that this is where the salters crossed this formidable barrier, but cross it they did and over a considerable period of time. The logical suggestion being they used boats, maybe there was a permanent ferry available here; however, it seems unlikely if we will ever find the answer.

From here the road swings northeast, following a route which takes us past Little Witley and on to Great Witley, between which the splendid shell of the once majestic Witley Court continues to give great delight to visitors today. Construction began in 1655 when it was owned by Thomas Foley. However, it was not until the early nineteenth century when John Nash brought his talents to Witley did the house achieve its reputation as one of the finest in the land. It had cost somewhere in the region of £220,000 to complete, an extraordinary sum of money in Georgian times. In 1937, the house was devastated by fire, since when great efforts have been made to restore parts of the building. In recent years, the spectacular Perseus and Andromeda fountain has been brought back to life, throwing a spout some 60 feet into the air, although this is only half its original height.

Nearing Great Witley, what was the Witley Road becomes Worcester Road, although still the A443. We have now travelled some five miles from Holt Heath and its crossing of the River Severn. After passing the Hundred House Hotel on the right, take the first

left along Stanford Lane. Within half a mile we pass Camp Lane on the left, which gives access to a footpath up Walsgrove Hill. While this does not have any link to the salt route, it does offer excellent views along the route back towards Droitwich and shows the terrain ahead. From here the road begins to wind and rise and fall, dropping down to cross the River Teme at Stanford Bridge.

This is not the original bridge, nor is the earlier footbridge a few yards upstream. The first documented bridge was of wooden construction and was replaced in 1548 by Humphrey Pakington of Chaddesley Corbett. The Teme has never suffered the pollution widely reported in other rivers in the latter half of the twentieth century. This has a lot to do with its course which takes the UK's 14th longest river on a 60-odd mile journey to its confluence with the Severn south of Worcester. During this time it drops from 1,700 feet above sea level to just 15 feet when it meets the Severn. As with the Severn at Holt Fleet, this tributary had to be crossed by the salters and, again as with the Severn, would not have been an easy task. However, the river was crossed and probably by means of a ferry service or, in summer months, on horseback at its shallowest point.

From here the route has suffered greatly from more recent agricultural boundary changes, making it a difficult route to follow. Doubtless in earlier times the track to Bockleton and on to Leominster was more direct, but today that is simply not possible and we shall follow a winding course along modern roads. Thus two miles on from the Teme we come to the crossroads where we cross the road from Clifton-upon-Teme and continue to pass the southern end of Upper Sapey at the junction with Church Lane, the attractive little church now visible is dedicated to St Michael and All Angels, shortly afterwards the curiously named Baiting House pub.

Half a mile on and we reach the crossroads known as Three Gates. A 'gate' here is an historical term, from Old English *gaet*, describing the entrance offered by the gap rather than the barrier formed by the gate across the gap which was a much later development. That there are three 'gates' or 'gaps' shows that one of these roads from this crossroad did not exist at that time, almost certainly the road to the left, which is directly opposite that which we will be taking.

Thus we turn right and travel a mile to a sharp bend at Upper House Farm. Here, behind us and to the left, is the site of the medieval village of Wolferlow. Little sign of the village remains today, aerial photographs show nothing, and it takes a very experienced eye to spot anything but the church which still dominates the skyline. St Andrew's at Wolferlow is built on a rise and is surrounded by a number of burials. The building is twelfth century, with extensive restoration in the nineteenth century and is listed Grade II. There was no single reason for the demise of Wolferlow, no major disaster befell the place; it simply ceased to be over a number of years.

The road turns north along the edge of the ridge, before diving down to pass south of Stoke Bliss and eventually turning right on to the B4214 Bromyard Road two miles away. Follow this road towards Tenbury Wells for just a mile and take the next road on the left to pass Kyre Park, with its church of St Mary and its medieval dovecote. Another two miles along and we come to the junction and turn right for the straight mile to Bockleton. From here we have surviving evidence of both the salters coming here and the road they probably took to Leominster.

Bockleton is listed in the Subsidy Roll of 1275, where there is a mention of one John de Saltereswelle. This is a place name meaning 'spring of the salters', although it is difficult to see exactly where this point is today. While we do know that the original track can be followed on foot this can be followed by what is today marked as the Herefordshire Trail. This 153-mile circular tour of the county has not been maintained and is today in poor condition and thus, even with the aid of a map, is very difficult to trace. Hence we are going to continue along the roads on this final leg of the journey to Leominster.

It should be said that a footpath leads from Bockleton Farm. Take the lane towards the church of St Mary, but walk straight past and through Bockleton Farm, following the footpath signposted to Grafton. This will take some distance of the route on foot and is more clearly marked than the Herefordshire Trail. Furthermore, it does bring us to a point we shall soon reach via a long loop to the north following the roads. While this is a detour away from the path taken by the salters, it is the easiest deviation to follow in the long term.

So continue on through Bockleton, following the road as it bends right. In roughly three-quarters of a mile take the road on the left and follow it around as it sweeps left and comes to Grafton, where those on foot will be rejoining us. Continue on along this road and we arrive at Pudleston in a little under two miles. The local church is dedicated to St Peter and has been extensively renovated to make it safe.

Continue straight ahead and follow the road to Brockmanton and to the junction where we turn left and then immediately right within 100 yards. Pause here and look directly opposite the direction of this road, for behind us is a row of trees which align almost perfectly with this road and where the road deviated from the straight path just before Brockmanton. It is easy to see how the road originally followed this path and the line of trees marks the original field boundaries.

Continue west and cross Whyle Brook as we follow this unnamed road as it winds two miles to the crossroads near Stretford. Straight across and we are on Tick Bridge Lane and on a mile-long stretch of road, where we cross Stretford Brook, and reach the busy A44 or Worcester Road. Turn right and follow the road into Leominster.

Modern building has erased any trace of the final destination of this salt route, yet we can be certain it would have ended up at the market place – be it directly or via a merchant. Salt was, and is still, used in an amazing variety of industries; it is not just the condiment on the table. And no more so than when this route was first travelled when it was, quite literally, worth its salt..

10

DROITWICH TO BRAILES

From Droitwich we need to follow the same route as detailed in Chapter 2, which runs to Warwick. Here we shall take the Salt Way out of Droitwich and, just after crossing the railway, will turn right at Gallows Green and travel along Goosehill Lane.

Here we shall travel the two miles along this road, emerging from the woodland to climb up to the first check point at the junction just before Phepson. Here take the road to the left and come the half a mile to the next recorded stop on the route, the hamlet known as Shell. Come down the slope ford the Shell Brook, head straight across the crossroads and climb the gentle slope to Earl's Common.

We are going to stay on this road for around three miles as it swings north and south. Here we pass Hollow Court which, as shown in earlier records, takes its name from the road referred to as Holloway. This road runs along a ridge and can only refer to the way the constant passage of carts had worn a dip and quite literally produced 'the hollow way'. However, in a document of 1275, this road is also referred to as Salteres Stret. Follow this ancient track until we reach the junction at Stock Wood, turning right along Stockwood Lane, right again at the junction along Withybed Lane, and left on to Stonepit Lane, which brings us into the centre of the town of Inkberrow and provides an easier route back on to the original course of the salt route. This route is also shown on an eighteenth century map of Inkberrow when the road is labelled Saltar Street.

Inkberrow may not be associated with salt, but it is associated with *The Archers*, the long-running radio series. The town is often said to be the basis for the fictional setting of Ambridge, while Inkberrow's Old Bull public house is said to be the inspiration for the Bull, radio's most famous pub. Take a left at the junction with High Street, then in fifty yards turn left and follow this road past the parish church of St Peter's on the right and the site of the short-lived Inkberrow Castle on the left. This fortification was built around 1154 but had been destroyed by 1233; all that remains is the rough outline of the moat.

This road runs for a mile northeast to join the A422, where we turn right and follow the salt route again for another two miles until we reach the junction with the road heading north to Astwood Bank. This crossroads marks the site of the old priory; indeed, the farm here is still known as Priory's Farm and there is still evidence of the old mill in the landscape in the form of the mill mound. This junction is staggered and we need to turn first left and then immediately right before a two-mile journey east to the village of Arrow.

To the south of this road is Ragley Hall, a seventeenth century mansion designed by architect Robert Hooke and completed in the eighteenth century by James Gibbs, with landscaping by Capability Brown. During both world wars it provided the grandest of hospitals for patients, while it doubled as the Palace of Versailles for David Tennant's *Doctor Who* in 2006. However, it is actually the official home of the Marchioness and Marquess of Hertford.

Arriving at the junction in Arrow turn right and in a quarter of a mile come to a large traffic island known as Arrow Roundabout. From here we have to decide on a route across the River Arrow, which today has a weir, making it deeper and impossible to ford, while in the days of the salters would have been easily fordable.

Undoubtedly in Roman times the salt would have had an outlet through Alcester tradesmen, while the main route went through Oversley Green to the south. There is no access to Mill Lane into Oversley from the A422 today; hence we head into Alcester town by taking the road opposite at the island known as Evesham Street. This brings us to another traffic island where we take the third exit known as Swan Street, and from there it becomes Stratford Road. Travel along here for a mile and then turn right on to Trench Lane, so named because it passes between two regions of high ground, to rejoin the A422 Stratford/Alcester Road along the same route as had been laid out by the Romans. There is documented evidence of the salt being brought to both Haselor and Binton via minor detours off this route, further evidence of the existence of the salters' route.

After approximately five miles we are on the outskirts of Stratford-upon-Avon; at the island ignore the Stratford By-Pass to the left and take the right fork along the Alcester Road. After five miles we are in the western outskirts of Stratford-upon-Avon at Shottery, home to Anne Hathaway's Cottage, the well known wife of William Shakespeare and whose name is synonymous with the town. To describe this building as a cottage is something of an understatement, for this is a large farmhouse with twelve rooms from at least the fifteenth century and, in Shakespeare's day, was the 90 acre Newlands Farm.

A charter of 1016 mentions *tha Sealstret* of Shottery and thereafter to cross Shottery Brook, evidence that the salters passed this way over 550 years before Shakespeare was born and 70 years before Domesday. Today this is Alcester Road, which we travel for a mile and a half into the effective centre of the town, albeit not the geographical centre. At the junction, head straight on, onto Greenhill Street, Rother Street, Wood Street and, of course, Bridge Street. The Avon is crossed at Stratford, as indeed the Saxon place name tells us as it is 'the ford of the Roman road'. Just to confuse matters, the town is Stratford-UPON-Avon, while the administrative district is styled Stratford-ON-Avon.

After crossing the river, note we have evidence of salt being taken to Wasperton to the northeast, effectively following the right bank of this famous river. Along the way the

salters would have passed close to what is now Charlecote Park and its Grade I listed building. The Lucy family had arrived in England with William the Conqueror in 1066 and owned this property from 1247. Successive generations built and rebuilt until the line died out and it was inherited by the Fairfax Baronets, who promptly changed their name to continue the traditional Charlecote line. The park coves 185 acres and, as with Ragley Hall earlier, was landscaped by Capability Brown.

Meanwhile, it is worthwhile taking a look at Clopton Bridge here, which is often ignored in favour of the Royal Shakespeare Theatre. As the name states the Avon was forded during Saxon times and, while it is not known when the first bridge was built, there was certainly a timber construction here by 1318. In 1480, Hugh Clopton of Clopton House financed the building of the bridge that took his family name. Repairs and rebuilds happened again and again – for flooding in 1588; in 1642, one arch had been destroyed to halt Cromwell's advancing armies; in 1696, the parapets were raised; in 1811, the bridge was widened; in 1814, the toll house was added to pay for the upkeep, and in 1827, a footbridge was added alongside the stone bridge of 14 arches.

The same Roman road continues on southeast; again designated the A422 or Banbury Road. This leg is a journey of almost six miles of uninterrupted straight road, save for the traffic islands where it leaves Stratford-upon-Avon and where we cross the A429 just short of Ettington, the next documented point on this route. However, there is no trace of Ettington on the later routes documented for the distribution of salt, for the place was then known as Eatington and that is how it is recorded. The change, which can only be due to a mispronunciation, must be very recent, for a significant portion of the local population still refers to the place as Eatington.

Ettington's history is long and largely unremarkable; even in the modern era the place has hardly grown, having a population of less than one thousand. At the parish church of Holy Trinity and St Thomas of Canterbury, famous composer and organist William Croft was baptised on 30 December 1678. Croft was organist at Westminster Abbey and composed music for the funeral of Queen Anne and for the coronation of her successor, George I. However, it is for his religious scores for which he is remembered, most notably the piece called *St Anne*, which we all know for it was used with the poem *O God Our Help In Ages Past*, a hymn which is still among the most sung in churches today. He also wrote several violin sonatas which have enjoyed something of a revival since the age of recordings.

Continuing along the A422 for three-quarters of a mile from the church, we come to an important junction in history, for this is where we meet a more important Roman road known as the Fosse Way, which runs between Exeter and Lincoln. It is a very straight route running for 182 miles and never deviating more than six miles of a direct line between the two cites. The name comes from a Latin term *fossa* and referring to the 'ditch' or drainage, at the time a feature unique to Roman roads and a unique name, for it is the only Roman road to have a Latin name, the rest invariably have Saxon or Old English names.

Roman roads in Britain measured 2,500 miles (compared to 13,000 miles in Gaul, roughly equal to modern France) and are today thought more as being earlier tracks which have been surfaced by the Romans, making them all-weather routes.

The Roman road, or *vaie* as they knew them, had to conform to the rules laid down in 450 BC as the Twelve Tables and did for the entire Empire. They had to be a minimum of 8 feet wide on the straight and 16 feet wide on a turn, were constructed by four layers of sands and rubble and topped off with paving stones, producing excellent drainage and a rapid means of moving from one place to another for those permitted to walk, drive cattle, vehicles, or traffic of all kinds. Unfortunately, the rules were flaunted and hardly any road in Britain conforms to all these regulations.

We turn right on to the Fosse Way and travel along here for half a mile and then take the next left towards Fulready and, half a mile along here at the junction, we find another reminder of the route taken by the salter traders in Salter's Barn.

Turn left at the junction on to the Pillerton Road and then a hundred yards right, which takes us to Fulready in half a mile. Little has happened at this tiny hamlet over the years and little change seems likely; without church records of note, we only find the diaries of those who took part in the Warwickshire Hunt including, in 1891, when a fox was pursued for ninety minutes on 17 November. Their quarry had checked back after seeking sanctuary on an island in the River Stour near Honington and had been flushed out, but not caught by the hounds. That the pack was slow dragging its collective self from the waters gave the fox a head start and it was pursued to Fulready, where the trail was lost and the fox escaped.

Continuing along this road it is just under two miles to Whatcote, via the aptly named Whatcote Bridge, which allows us to cross Wagtail Brook. The salters undoubtedly forded this minor watercourse, which takes the name of the bird owing to it running through a series of many tight but tiny bends.

At Whatcote we find the twelfth century church of St Peter, although only the nave is original and the remainder has been rebuilt or replaced over the intervening centuries almost up to the present day. For those desiring a break and refreshment the Royal Oak, a pub name reminding us of the time when Charles II fled the Battle of Worcester and hid in the Boscobel Oak from the Parliamentarians, will fit the bill perfectly.

From Whatcote there is an obvious line where a path heads towards Compton Wynyates, not the route taken by the salters (as far as we know) but the remnants of a Roman road. However, we take the road south for a mile and a half to the crossroads near Nineveh Farm – not a biblical name but what is referred to as a 'remoteness' name, a humorous comment on the most distant corner of a parish and thus a long way to travel. Cross directly over and travel the remaining mile and a half to Brailes.

Officially two places here, Upper Brailes and Lower Brailes, although the two are so close they are invariably referred to as one place, Brailes. The most obvious target here is Castle Hill and the easiest way to reach this is via Castle Hill Lane, directly opposite the road from Whatcote. This should not be mistaken for the road on the right at this crossroads, somewhat confusingly called Castle Hill, which does prove an alternative route to Castle Hill, but a much harder and less obvious one to follow.

Approximately 600 yards down this slope there is a footpath heading off to the left, although the motte and bailey which is Castle Hill is clearly visible. An earthwork is still visible surrounding the site, while there are the remains of the mound some 500 feet above sea level and an oval 30 yards at its widest and just 10 yards the opposite way.

This artificial mound offers good views over the countryside, although it seems odd that the flat top of Brailes Hill was not chosen as it rises another 250 feet above this point; indeed, it is claimed as the second highest point in Warwickshire. At Lower Brailes is the church of St George, which glories in the title of the 'Cathedral of the Feldon'. This is a Saxon word referring to 'an area of felled woodland'.

As we have noted several times, the Roman road and the salt route have a common ancestry, for both use the track from Droitwich to Brailes. There are no references to the salt in Brailes, but evidence of the Romans has been found in the form of enough artefacts to suggest there was once a sizable villa around here. However, many centuries of the plough have broken up these remains and strewn them everywhere and, to the trained eye, are still to be found around both Upper and Lower Brailes.

This is but one route in this direction from Droitwich. A couple of offshoots were pointed out either side of Stratford-upon-Avon; however, in the next chapter, we shall double back to Ettington and follow a second route into Buckinghamshire.

11

ETTINGTON TO PRINCES RISBOROUGH

As we saw in the previous chapter, the route from Droitwich brings us to Ettington and from there, those few hundred yards to the junction with that most famous of Roman roads, the Fosse Way. It is at that junction where we will begin this side salt route.

So from this junction we shall continue along the A422 Banbury Road towards Pillerton Priors, just over a mile away. There is no church here today; the religious connection seen in the name is only seen today in what remains of the churchyard.

It is a little over a mile out of Pillerton Priors that an unnamed road on the right leads to the next point on the route; halfway along is a cone-shaped hill on the right rising to just under 400 feet above sea level called Windmill Hill. To have this name, it must have been connected with a windmill in some way; however, this would have been short-lived and indeed, may not have been completed, for this is the only surviving reference we have.

Take this unnamed road which leads to the village of Oxhill a mile away. This road brings us to the junction with Kineton Road where we turn right and follow this road as it sweeps around and becomes first Main Street then Church Lane, before turning right and heading towards Upper Tysoe along Tysoe Road. Before leaving Oxhill, we should note that the church of St Lawrence is the last resting place of Myrtilla. Church records state she was buried here on 6 January 1705, was 'the negro of Mrs Beauchamp', and said to be a former slave and the only one with a grave in the county. For the lady to have taken the trouble to organise and pay for a proper funeral is probably an indication that Myrtilla was held in high esteem and did not suffer in the service of her mistress.

Entering Upper Tysoe the road becomes Oxhill Road; at the junction turn left on to Main Street, and then left on to Middleton Close, which brings us through the village and along a mile of road which will challenge us with a steep incline rising to the top of the escarpment some 250 feet above the village. Just south of the village is another conical hill, almost level with us above Compton Wynyates. This is another Windmill

Church of St Lawrence, Oxhill.

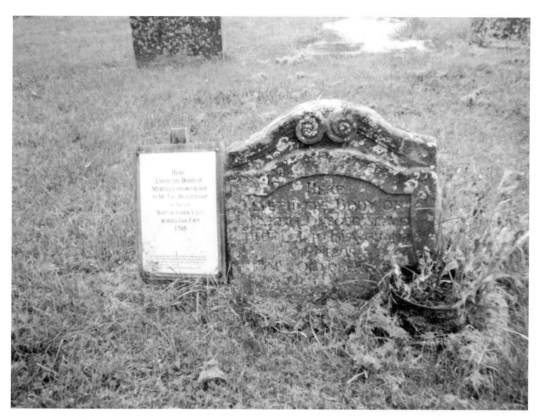

Grave of Myrtilla, at St Lawrence church, Oxhill.

Hill; however, here the windmill is still visible. It was built in the eighteenth century and worked until struck by lightning in 1915. Restoration began in 1935 and was completed by 1975, thanks to the efforts of the Marquess of Northampton.

Reaching the top of Tysoe Hill we reach a crossroads, known as Christmas Corner, where we cross from Warwickshire into neighbouring Oxfordshire. Continue straight over to round Shenlow Hill, turn south and then swing southeast to where the lane becomes Epwell Road and enters Shutford some three miles from Christmas Corner. Shutford was renowned for the production of plush, a fabric similar to velvet and much prized by royal courts all over Europe, in Africa and the Far East, and also used to amuse children over the centuries, when it was used as the fur for stuffed toys – indeed, the French term for a teddy bear is *ours en peluche*. The industry was the domain of the Wrench family, who provided local employment from the early seventeenth century right up to 1947 when it became cheaper to produce the plush using synthetic fibres.

Along High Street we pass through the hub of the village. St Martin's church is alongside the fine Manor House and near the George and Dragon, which today is as much a restaurant as it is a pub. While the pub is said to be thirteenth century, parts of the church are Norman. It came as no little surprise to find this was yet another village where there was a mysteriously lost tunnel between the two buildings. While church

Idyllic scene at Shutford and St Martin's church.

The Blinking Owl at North Newington.

and pub are often closely linked, the number of stories the author has heard of a tunnel between the church crypt and the pub's cellar are too numerous to count. However, there is always the chance that this is the one, which demands a closer look.

To the south of the village is Jester's Hill, easily recognised because it supports the Shutford Beacon, erected to mark the 50th anniversary of VE Day on 8 May 1995. The hill is named after a local family; the grave of William Jester is still to be seen in the churchyard. At Easter, villagers join in with an Easter Egg Roll when eggs – hard-boiled, not chocolate – are decorated and rolled down the hill pursued by their 'owner'. The origins of this tradition are unclear, as are many supposed Easter rolling traditions.

High Street arrives at the junction where, directly opposite, is Banbury Road once more, but heading off at a strange angle to the left. This brings us to another junction just 600 yards away, which tells us what to expect for it is marked on the map as Five Ways, when in effect it is simply a matter of continuing straight ahead, treating the other three lanes simply as side roads. Indeed, it is another two miles before we come to the village of North Newington, along what has now become Shutford Road, and on entering the village itself is called High Street.

Canal as it heads under the Aynho Road ...

The local here is the Blinking Owl, a unique name for a pub from a highly unusual source. When the current proprietors moved in what is now the restaurant was a wood store; when they had to collect the wood for the open fires it seemed every time they opened the doors a barn owl flew out, making them jump as it flew inches by their heads in its silent flight, when all that could be heard in the near darkness was, 'Oh, that blinking owl!'

Continue on along the Banbury Road and head out of the village. In half a mile we reach a junction, near where the North Newington Mill was powered by the River Sow, turn left and in another 600 yards we come to the B4035 Broughton Road. While the map shows a footpath directly ahead it is not very obvious from here, so we turn left and in a few yards find another footpath clearly marked on the right. Follow this and, as it bends around to head east, we are on the old salt route, still shown as such on the maps. For those with a vehicle take a right along the A4035 to Broughton and, at the crossroads, turn left along Wykham Lane to Bodicote where the two routes reunite.

The salt track skirts the southern edge of Banbury for two miles. There is a delightful newly-created pathway lined by trees; halfway along this we cross the Bloxham Road before continuing on to reach a new road which carries a brand new nameplate with the ancient name of Salt Way.

... and also the valley of the Cherwell river and the railway beyond.

At the end we turn right on to White Post Road, and in a quarter of a mile reunite with the road traffic at Wykham Lane and continue along High Street for a further quarter of a mile, then turn left on to the appropriately named East Street. While there are no remaining signs of a salt route running into Banbury, there can be no doubt that the town received its share. Furthermore, Bodicote would have also received a delivery, for there was a Romano-British settlement here, and an ancient cross stood until the eighteenth century which is evidenced by the name of Weeping Cross, the next road we find ourselves on. What is certain is this village with a long history is fast disappearing under the influences of the twenty-first century and Banbury to the north.

We are now at the junction with the A4260 Oxford Road and turn right on to it. The road follows a gentle mile and a half sweep south to Adderbury. Actually, there are two settlements here, East and West Adderbury, separated by the Sor Brook. The parish church of St Mary the Virgin, east of the Sor, is one of the largest parish churches in Oxfordshire and one which exhibits various styles owing to its many rebuilds over the centuries. A nearby tithe barn dates from the fourteenth century.

Perhaps the most influential building is Adderbury House, built in East Adderbury in the seventeenth century by Henry Wilmot, Earl of Rochester who fought in the English

Civil War with Prince Rupert of the Rhine. Since then it has been redesigned several times: in 1661 by Anne Wilmot, Countess of Rochester; in 1722 by John Campbell, Duke of Argyll; in 1731 by Architect Roger Morris; and in 1768 by Henry Scott, Duke of Buccleuch. However, the present house is largely nineteenth century after being demolished in 1808. In the nineteenth century, when Major Lamach owned Adderbury House, his horse Jeddah won the Epsom Derby at 100-1 and later won a valuable race at Ascot. The proceeds enabled him to finance the building of the Village Institute which has been the focus for village life since it opened in 1898.

Yet the salt route turns off the Oxford Road shortly after entering the village of Adderbury and turning left along the B4100 Aynho Road, with the village of Aynho just over three miles away. Just after halfway we encounter no less than four obstructions; only one of these would have hampered the progress of the salters. First we meet the Oxford Canal, built between 1769 and 1790; its 70-mile length features 43 locks and one tunnel. Constructed to link the Grand Union and Coventry Canals in the north with Oxford and the Thames, it enabled goods in the Midlands to find a way to the international docks of London. Surveying of the route began with the man whose name is synonymous with the construction of the canals, James Brindley. Sadly, Brindley died in 1772, and thus the task fell to Samuel Simcock, who had excellent credentials, for he was not only trained by Brindley, but the two men were also brothers-in-law.

Within 200 yards we have found the only one of the obstacles which would have confronted the salters on their journey, the River Cherwell and one they doubtless crossed with the aid of a boat or raft. One of the major tributaries of the Thames, the riverbed would have suggested the route for the canal – indeed, it was once considered for 'canalising'. Looking down from the road let the eye follow the course of the river and watch it disappear under the railway tracks of the Cherwell Valley Line. This scenic route, which benefits from having few cuttings to spoil the view, links Banbury and Didcot and is of increasing importance, allowing freight to travel from Southampton into the Midlands.

In another 800 yards we pass over the most recent obstacle, the M40 motorway here being built between 1990 and 1992. At the time of its construction it was to have been the final major motorway route in the country, although before completion other plans were already under consideration. The motorway did produce the best known modern reference to this area, and it is sad to think this delightful piece of England has a name which is synonymous with that of the Cherwell Valley Services.

Entering Aynho, the self-styled 'Apricot Village', follow the route of the B4100 as it enters the settlement and becomes Roundtown (a pleasantly different name for a by-pass), then Coughton Road. However, on foot the one-way system will prove no obstacle and thus we go on to Banbury Road, Hollway, and The Square before rejoining Coughton Road. Three quarters of a mile east of Aynho turn right at the crossroads and head south along the B4100 until, in half a mile, we skirt the village of Souldern.

This leg of the route has few, if any, signs of the old salt route; a look over the hedgerows offers a clue as to why. This is farming country, agriculture having dominated this fertile region for centuries. As any archaeologist knows, the plough has destroyed more historical evidence for a longer period than everything else combined. Records also

tend to ignore minor information in favour of the big picture; hence the older route is not mentioned while the return from the fields of crops dominates the pages.

Past Baynards Green and across the intersection with the A43, we pass through Bainton and Caversfield and head into Bicester along the B4100, as Banbury Road, North Street, St Johns Street, Manorsfield Road, Market Square, and London Road, emerging to turn left on the A41 Aylesbury Road at the traffic island, having now travelled some seven miles from Souldern.

Following the A41 for ten miles, we then pass through Kingswood and Woodham to reach the right turn for Westcott along High Street, which then becomes Ashendon Road. Westcott was the site of an old RAF airfield, later the Rocket Propulsion Establishment. Another three miles along and we enter the village of Ashendon, where the Gatehangers Inn offers refreshment to the weary traveller, as we make our way along Main Street.

Continue along this road, until it becomes Cannon's Hill, which leads to Bridgeway where we turn left, and then down Cuddington Hill into the village of that name. Old records suggest this was a place of pilgrimage, where a spring was said to have great medicinal or curative properties, although the location of same has never been found. During the Second World War, the King of Norway was offered accommodation at the seventeenth century Tyringham House here.

The route turns right as soon as it enters the village, heading south along the road named Dadbrook, crossing the A418; we then continue on Church Way into Haddenham, turning left onto Stanbridge Road. At the junction turn left and the next point of reference lies up a road on the left in the form of Aston Sandford.

Continue on and reach the A4129 Thame Road; turn left here and follow this road for a mile through Longwick and enter Princes Risborough. In the fourteenth century, this town was in the hands of Edward the Black Prince, who had a substantial home here. In the town centre, the market house is an indication of how long this has been an important market town. Indeed, it also stands on an ancient trading route between Winchester and Cambridge.

While there are breaks in the evidence of a salt route to here, it is almost certain that this is as close to the original trackway as it is possible to get in the modern era. It is also likely that a thorough and protracted search of records with a fine toothcomb will reveal the odd clue that salt came through this way.

12

NORTHWICH TO THE WORLD

This route is rather different from the rest and for several reasons. Firstly, it is not strictly an ancient route, although the origins are much earlier than the early eighteenth century version of the route we shall be following. Secondly, the volume being transported cannot be compared to that being carried by pack horses. Finally, the ultimate destination for the product was, even today, distant lands which most will never see.

Prior to the arrival of the Romans, the area around the River Weaver was largely wooded. Any traveller sought out natural fords to cross to head north, one of which grew to become the town of Northwich. Since before Roman times, the extraction of salt from the brine springs had provided the locals with a means to trade. The use of salt in cheese making produced the famous Cheshire cheese. The distribution of the local cheese saw a significant increase in sales from the middle of the seventeenth century when the London market opened. Previously, cheese had been taken to the capital from the fertile flatlands of Suffolk but, following an outbreak of disease in cattle which severely affected dairy farming in the county, a readily available source was found in Cheshire. This not only meant more demand for cheese but also more dairy herds and more salt.

During the winter of 2008/9, the heaviest snowfalls for twenty years put a strain on the supplies of salt and grit which is normally spread on our roads with hardly a second glance from the general public. The extraction of salt in commercial quantities did not begin until the coming of the canal. In 1675, it was estimated that transporting goods by road cost twelve times that of moving goods on the water. A statistic which must have influenced the creation of the canal system, with the realisation that it was possible to move vastly bigger payloads afloat with one horse than it was overland with two or more horsepower.

To show how productive these salt mines were, we will take a look at just one decade. In the 1880s, when extraction methods were nowhere near as efficient as they are today,

the statistics are impressive. During those ten years, salt was shipped from the ports of Liverpool, Runcorn and Weston Point around Britain across Europe, North and South America, East Indies, Africa and as far as Australia and New Zealand. Over one million tons of rock salt left the quaysides, yet this pales into insignificance when compared the refined product, known as white salt. A grand total of 9,067,468 tons of white salt was shipped to all corners of the globe, half of which was delivered to just two locations: USA and the East Indies.

To transport such vast quantities along the roads would have been impractical. However, there was a natural solution and in 1721 an Act of Parliament made the River Weaver navigable from Winsford to Frodsham Bridge, providing the depth did not exceed 4 feet 6 inches. At the end of the nineteenth century, the Weaver Navigation was 'the largest inland navigation in the kingdom'.

Eventually the salt from Winsford and Northwich made its way to the Weaver; Middlewich being served by the Trent and Mersey Canal. At Winsford, the modern jetties giving access to the leisure industry are a reminder of the commercial jetties and quays which once lined the shorelines here. Travelling north, it soon becomes apparent which stretches are natural and which are a result of one of the many stages of construction, as the artificial river was enhanced to carry ever larger craft and greater cargoes.

Passing under the bridge at Moulton, the Weaver enters the very straight Valeroyal Cut as it runs parallel to the railway which has served Manchester and Liverpool for many years. As we reach the Valeroyal Locks, approximately three miles from Winsford, the still impressive sight has another Weaver to the west and that is the original River Weaver, rather dwarfed by the newer navigation. Shortly afterwards the now electrified railway line bridges the navigation and then the Hartford Bridge, opened in 1938 and also called the Blue Bridge, a single span bridge which carries the A556 by-pass overhead.

After the marina, once Pimblott's Shipyard, we encounter more locks and then the viaduct carrying the railway. We are now in the heart of Northwich and there are still reminders of the sort of vessels which used to be a common sight on the Weaver Navigation. Just afterwards, now some eight miles from Winsford, the navigation arrives at a junction where we take the left turn and come to a sight which cannot be missed.

As production increased, the extra volume meant cargoes of salt had to be transferred between the Weaver and the Trent and Mersey Canal, while coal was shipped in the opposite direction as fuel in the evaporation of the brine in the salt pans – a ton of coal being required to produce two tons of salt. As there is a 50 feet difference between the two, a solution was required and that came in the form of the Anderton Boat Lift.

The hydraulic boat lift, designed by Edward Leader Williams, was known as the Cathedral of the Canals and is the oldest working boat lift in the world. It was copied for other lifts in Europe and Canada. The term 'boat lift' suggests it was just the boat which was lifted, when it was also the caisson (a removable section of canal) and the water which floated the boat and its cargo which was lifted, a gross weight of over 300 tons. This is not as tough a job as it sounds for there was a second caisson which counterbalanced the weights.

It took less than ten minutes to complete the lift, or descent, through this wonderful piece of Victorian engineering which was powered by steam until 1913, when the

mechanism was converted to electric by John Saner. However, the level of chemical pollutants in the Weaver was corroding the hydraulic rams and remained a serious problem until the pollution problem was solved. In 1979, the Anderton Boat Lift became a scheduled monument, only to stop working in 1983 when serious corrosion problems were discovered. British Waterways were unable to fund its repair and it stood idle for twenty years until hard work and fund raising produced £7 million to repair the lift. By the time it lifted its next boat, 3,000 components had been restored, 1,000 individual repairs were done, and over a mile of welding had been completed.

Shortly afterwards there is a second split, where the salt followed the right line under the A533. The line to the right passes a weir, an interesting swing bridge, then a second weir when the two meet up briefly in half a mile before the navigation loops around in what is known as the Barnton Cut.

As we approach ten miles from Winsford we come to the next set of locks. Significantly, they are called Saltersford Locks; the ford in question would have crossed the original River Weaver and a route to the north. Another mile and we pass under the single span bridge at Acton Bridge which carries the A49 north to Warrington. Just before a fourth set of locks there is a loop of the River Weaver across a sluice, which may be of interest, although the boats would have carried on through Dunton Locks, under the railway once more and through Pickering's Cut, Frodsham Cut and Frodsham Lock.

The Salt Museum, Northwich.

The canalised River Weaver.

The town of Frodsham is one of only seven manors listed in Domesday as having salt rights. Salt rights meant they were exempt from paying taxes and tolls, receiving the allocation annually directly from the saltworks. Later it became an even more important stopping place for, from 1697, rock salt was brought here for the salt refinery at Hale and thereafter shipped abroad. However, in later years the salt went the full 20 miles to the Manchester Ship Canal and Weston Docks.

13

MIDDLEWICH TO SHOTWICK

It is said every journey starts with a single step; however, not every first step is taken from the same place and in the same direction. To trace any route we obviously have to have a starting point and in Middlewich there are a number of choices from a number of eras. Hence we shall opt for the oldest known, which is probably that near the Roman fort in what was once Harbutt's Field and later known as Kinderton Salt Works. This is also conveniently close to the A54 Chester Road, the old route we shall be following towards the county town and beyond.

Thus we find ourselves on King Street on the corner with Hadrian Way, for no other reason than it provides a link with the Roman history of this place and is as close as we can be certain that this was where the Romans mined the salt. To the Romans, Middlewich was known as *Salinae*, while by the Domesday survey all the Cheshire Wyches were the property of Earl Hugh, where one-third of all the tolls and profits went to him and the remainder to the Crown. It is likely that this was later the site of the salt works belonging to Peter Venables, the Baron of Kinderton in 1671. By 1682, it had seven salt pans producing 2,210 bushels of salt each and every week. A bushel, often said to be a measure of weight, should be viewed as a measurement of dry goods by volume. It equates to 8 gallons volume, which cannot be said to be equal to a specific weight as it clearly depends upon what is being produced. Originally, the bushel was employed for measuring grain only.

We cannot leave Middlewich without mentioning the former salt works rebuilt by Henry Seddon in 1913, which was merged with the Cerebos salt company around 1958, and which closed for the final time in 1970 and demolished five years later. Nothing unusual there; however, there is a certain irony that this factory was in Pepper Street!

King Street was not only the Roman site but also thought to have been where the Iron Age tribe the Cornovii extracted salt. King Street forms part of the Roman road between Northwich and Middlewich; remains of a fort and a well were uncovered during a twenty-first century archaeological dig. There is also strong evidence to suggest this

was also an earlier Neolithic trade route, wherein stone axes from Northumbria were brought here. It is tempting to suggest such were traded for salt.

We then head south along King Street to the junction with the A54 where we turn right. As this road passes through the town it has several different names, including Kinderton Street, The Bullring, St Michaels Way, Newton Bank and Chester Road. Shortly after leaving the town it becomes Middlewich Road, the road looping around to the outskirts of Winsford and the region known as Clive. Shortly afterwards we come to the local railway station and then the traffic island which takes the modern A54 by-pass around the eastern half of Winsford. However, the salt route would have originally continued straight on, following the B5355 Station Road, which follows an almost perfectly straight line before rejoining the modern A54.

Continue north and we come to the crossing point at the start of the Weaver Navigation, and then negotiate the large island crossing the canal and continue along the A54 or High Street. After two miles we come to another traffic island where we turn right off the A-road and on to Delamere Street. We are now in the district of Over, where there are two historical references to the salters' route: Saltereswey, which is almost certainly the road we are on or that ahead of us, and Salterswall which is the region three-quarters of a mile ahead of us.

Delamere Street crosses into the region of Littler and becomes Chester Road once more, climbing the hill to the hamlet of Salterswall, a place name which where the suffix comes from Old English *halh* meaning 'the nook of land' and the first element self-explanatory. Shortly afterwards we rejoin the A54 once more and will be following this A-road for much of the route. After a little more than two miles, refreshment is available in the form of the Shrewsbury Arms north of Little Budworth, best known for being home to the Oulton Park racing circuit.

From here it is a straight road of almost seven miles, as we are taken a little to the north of directly east thus avoiding the higher ground in plain sight to the south. On the outskirts of Kelsall the by-pass takes us north of the village; however, the traditional road leads off to the left in the form of Chester Road, which gives way to the Old Coach Road, and runs back as Chester Road and, after approximately 2½ miles after leaving the A54, we rejoin that A-road.

However, that is not the end of the story with Kelsall, for here we find signs of an old Roman road which follows a direct line straight to the heart of Chester. Although it is difficult to follow in parts it is marked on modern maps, with a good length of the route visible passing north of Tarvin, our next port of call to Chester. While it might seem appropriate to follow the line of the Roman road, it is not practical in the twenty-first century; later records show this has not been followed since long before the Roman road was totally obscured by vegetation and/or the plough. Hence we shall continue along the A54 Chester Road.

Just over half a mile from rejoining the A54, we pass Street Farm (itself named from Old English *straet* or 'Roman road') on the right hand side, where Ashton Lane heads north. Here, walking a few yards up the Ashton Road and lining up with the hedgerow bordering the fishing pools just in front of us, we are looking towards the city of Chester and directly along the line of the old Roman road.

A better clue to the salt route can be found half a mile further along at a lay-by to the north of the road. Here is Brook Farm and, trickling down the west side of the farmyard, is Salters Brook. Over the years this crossing point has been recorded as Saltersford and Saltersford Bridge, although undoubtedly the place was originally forded. From here the name changes to the Kelsall Road and, another half a mile further along opposite High Street, is another point where the name changes again, this time to By-pass Road. It is also the point where Tarvin Bridge crosses Tarvin Brook downstream from Tarvin Mill. Previously this bridge was recorded as Saltersbridge, distinct from the previous name of Saltersford.

The name of Tarvin is derived from a Welsh word meaning 'boundary'. A tenth century Saxon cross was unearthed in the village; it had been placed in a ditch which appears to have been dug around the time Tarvin was the sight of an encounter in the English Civil War in 1645. As the road passes Tarvin the name changes over the next mile and a half to become Kelsall Road, By-pass Road and Holme Street, bringing us to the traffic island where we meet the A51 and, under this new designation, continue on towards Chester.

In three miles we arrive at the intersection with the A55 and pass through the district of Vicars Cross and Boughton Heath, via Tarvin Road, Vicars Cross Road, a further stretch of Tarvin Road, Boughton Road, and The Bars, before turning right and coming around St Oswald's Way, turning right at Upper Northgate Street, and on to Park Gate Road or the A540. The park refers to the estate surrounding Shotwick Castle; built by Hugh Lupus 1st Earl of Chester in 1093, all that remains of the Norman castle today is the remains of the motte and bailey. Travelling just over a mile along here we come to the A5117, over the majority of this length of road we have been parallel to the official border of England with Wales and we are soon to come much closer.

Turn right on the A5117 and, in a quarter of a mile, come to the A550 Welsh Road and turn right. In 600 yards we come to Shotwick Lane, a road which we take into this tiny village which has a rather more grand history than it would seem today. For example, this is where two kings embarked on voyages for Wales, in the case of Edward I in 1278, and Ireland was the destination for Henry II, as Shotwick was once a port. Over the years the Dee has silted up and the estuary is now some two miles from Shotwick. Further evidence of the changing coastline is seen at Shotwick Castle, now even further from the sea, but was once defended by a moat which flooded to a depth of 10 feet and a massive 80 feet wide.

The castle, and for that matter the port, of Shotwick played important roles in the border conflicts over the years. A little walk along Green Lane West to the line of the hedgerow in front of us and we reach a border which would once have been defended on both sides. However, today the Welsh border with England is difficult to locate.

Whether salt crossed the border here seems unlikely. However, there is every chance the port of Shotwick would have shipped some around the coastline. Unfortunately, there is no record of such.

14

NORTHWICH TO HINDLEY

Extracting rock salt over a number of years leaves great caverns. To prevent the collapse of the roof, columns of salt were left, much like the interior of our churches. However, the problem came in the form of water, which seeped into the caverns through the old bore holes and dissolved the salt. As the brine level increased so did the rate of erosion. Eventually, subsidence became a problem in the town known as Condate to the Romans.

On 6 December 1880, a rumbling was heard, while the land over the disused mines began to resemble the epicentre of an earthquake zone as the land was seen to roll and heave. The water in the bore holes was seen to boil, water being thrown out, while the smell of the escaping gas was described as 'most foul'. Worse was to come as the land fell in and the pressure forced intermittent jets of muddy, salty water 12 feet into the air. The initial outburst lasted for almost four hours, but minor 'after shocks' occurred on three consecutive days. What had been the basis for Northwich's success for centuries was proving a disaster as subsidence moved most buildings in the town to at least some degree. Rather than move away the buildings were jacked up, while later investigations revealed there had been a slip and the resulting fault had allowed the Wincham Brook to flood into the mines.

In recent years, the town has taken action to prevent further subsidence. A special concrete mixture is being pumped into the old workings and refilling the huge gaps left by salt extraction. This will not only reinforce the caverns but also help to prevent a repeat, should underground water damage again prove a hidden problem.

A route which heads north for twenty three miles starts on a route we looked at earlier. There is no suggestion of this being the starting point, simply that the route has to start somewhere and there would have been some exchange between routes. Standing on the bridge carrying Watling Street over the Weaver Navigation head east, following the A559 as it becomes Chester Way. In three-quarters of a mile take the second exit

The Salt Barge pub, Marston.

at the traffic island, the B5075 New Warrington Road and we are soon out into open country.

To the left are the open areas known as Ashton's Flash and Neumann's Flash, once wastelands which were the direct result of the salt and chemical industries of Northwich. Now Mother Nature is making a comeback, helped by the appointed Land Reclamation Team, a network of footpaths and bridleways has been created. The open land has been managed to provide habitats for many plants and animals, some of which are quite rare, such as the Marsh Orchid, Great Crested Newt, and Dingy Skipper Butterfly.

Here the road becomes Ollershaw Lane, passes the site of the old Lion Salt Works, crosses the Trent and Mersey Canal and, five miles from the start, come to the junction with the A559 Marston Road at Higher Marston. Just after a right hand bend the road becomes Northwich Road, passing Budworth Mere on the left, Great Budworth and Budmere Heath on the right, before coming to Gibb Hill. The road describes a loop to the west at Frandley; clearly the footpath which straightens this bend out is the original route of the road, although not for several centuries. Shortly afterwards we come to the Antrobus Arms; a recent name for this was originally the Wheatsheaf public house.

Seven miles into the journey we come to Lower Stretton and the refreshment stop that is the Birch and Bottle public house. The name Stretton is quite common in England; it comes from Old English *straet tun* and refers to a 'settlement on a Roman road'. While

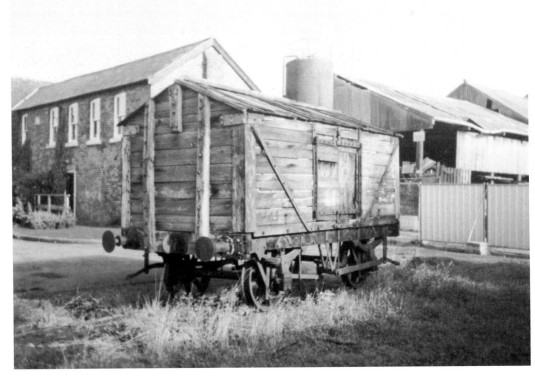

Old salt wagon at the restored Salt Works, Marston.

there is no archaeological evidence of a Roman road here, the name is sufficient, for the Saxons would have seen it. However, there is a Roman road north of here, and one equally important as the M56 which would have been a terrifying sight to the salt traders of two thousand plus years ago. Today, junction 10 simply allows access to and from the motorway, while we join the A49 and continue straight ahead into Warrington.

This was not always the layout of the road for, prior to the building of the motorway, these two A-roads united at Stretton half a mile north of here. This route can be followed by ignoring the A49 to Warrington from this island and taking the next exit along Spark Hall Close and the Stretton Fox public house, well known in the area for its fine food and beverages, well maintained gardens in summer and roaring log fire in winter. Follow the line of Spark Hall Close up to the Park Royal Hotel and the church of St Matthew's, which was the work of the Starkey family who held the man of Stretton from the reign of Henry II (1154-89) until the early eighteenth century. Thereafter, there is a footpath through Appleton Park, in places lined by an avenue of trees, which follows the line of the original Roman road. For those able to follow this course there is surely a satisfaction from following this route which would have been taken by the salters as well as the Roman-British population. Alternatively, follow the Stretton Road to the left, and then right along the A49 London Road, reaching the traffic island where the alternatives meet once more.

Continue north along London Road, again along the line of the original Roman road, follow it as it deviates from the original path until, a mile and a half from the island,

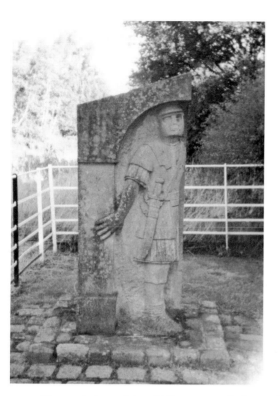
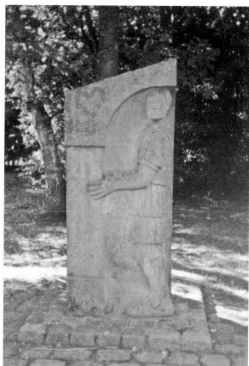

The reminders of the old Roman road along which we are walking at Stretton.

we reach the Bridgewater Canal. This was built by engineers John Gilbert and James Brindley; opened in 1761, it is often quoted as England's first 'true' canal and certainly features the first viaduct on a canal, enabling it to cross the River Irwell. It is today one of the many waterways open to leisure craft and forms part of the Cheshire Ring canal network. Six hundred yards further along we cross the much larger Manchester Ship Canal. Built between 1887-94, when it was the largest navigable canal in the world, it is no longer an important route but still carries million of tons of freight each year. Here it is crossed by a swing bridge, along the Wilderspool Causeway, built to accommodate a horsedrawn tramway at the beginning of the twentieth century.

While the salt would have travelled these canals at some time in their history, the salt would have been carried here even before the Roman road arrived here. This is now the district of Warrington known as Latchford, which was long a settlement in its own right, a place name which means 'the boggy stream ford' and doubtless a river crossing used by the salters as they made their way across the River Mersey. We cross the Mersey via the A49 a mile after the canal, staying on the A49 through Warrington as it becomes the Wilderspool Causeway.

Over the River Mersey itself and the A49 becomes Mersey Street, which we follow through a series of traffic islands as the A-road becomes successively Fennel Street, Lythgoes Lane, Winwick Road, and Newton Road where we cross the M62 and leave Warrington. As we cross over the motorway we have travelled two and a half miles from

the River Mersey, through a town where modern developments have erased all signs of the salt route.

Across the motorway we approach Winwick, a village lying between the M62 and the M6. However, it retains its village identity and has a long and interesting history. The parish church is dedicated to St Oswald, King of Northumbria from 634 to 642. Legend has it that he was killed here, by the pagan King Penda of Mercia, the exact place being identified by the Winwick Pig who carried the foundation stones upon which the church was constructed. Whether this was where Oswald died is uncertain; however, we do know that this was where one Sarah Eleanor Pennington became Mrs Smith on 13 January 1887. We also know that Mrs Smith went on to become one of the most famous widows in history, for her husband was none other than Captain Edward J. Smith, who was in charge of *RMS Titanic* in April 1912.

The church is clearly visible as we enter Winwick, coming along the A573 Newton Road and thereafter right along Golbourne Road. Three-quarters of a mile along is Hermitage Green, a reminder of this being a religious site where pilgrims came (and clearly at least one stayed) for, as this becomes the Parkside Road, we find St Oswald's Well on the left of the road.

Another mile and a half further along and we arrive at Parkside Liverpool Railway Junction, a region known as the Town of Lowton, little more than a hamlet but a name which distinguishes it from neighbouring Lowton Heath. As we arrive at the junction with the A572 near Sandfield Hall, we need to take a right turn out of Parkside Road and an immediate left to find ourselves on Golborne Dale Road, which very soon becomes the Warrington Road after passing beneath the railway bridge.

Another half a mile and across the junction with the dual carriageway of the A580 to enter Golborne, best known for being alongside Haydock Pack Race Course. Golborne is said to have been founded by a legendary knight, a man so formidable he took on and defeated a dragon and his great deed rewarded by the granting of these lands to do with as he desired. It seems he desired to obliterate every reference to the salt route, for there are no references in this town today or historically.

Hence we make our way through the town, continuing to follow the A573 as it is known as Bridge Street, High Street, Church Street, and Ashton Road, we come away from Golborne on the Wigan Road and the end of our journey is fast approaching. Another mile and we find the road is now called Aye Bridge Road, which crosses Aye Bridge over the Hey Brook before coming to the Leeds and Liverpool Canal, crossed by the Dover Bridge. This waterway was started in 1770 and the 127 mile canal fully open in 1816; it was brought through this region in order to provide a transport link for the Wigan coalfields.

Across the canal we pass through the village of Abram, a journey of a mile and a quarter along Warrington Road where there are no signs of the salt route, for the village is simply not old enough. Abram is not mentioned in Domesday, the earliest record coming from 1212.

The town hit the headlines in 1908 when an explosion deep underground tore through the Maypole Coal Pit at 5 p.m. on 18 August. Investigations revealed a build up of coal dust, gas and the explosives used in mining proved a lethal combination which took the

CHESHIRE
1896
COUNTY COUNCIL

STRETTON 2½ MILES WARRINGTON 1 MILE

GREAT BUDWORTH 7 MILES

NORTHWICH 10

Road sign at Wilderspool Swing Bridge across the Mersey Canal, showing we have travelled ten miles from Northwich.

lives of 75 men and boys. In that moment, Abram gained 44 widows and 120 children lost their fathers. So deep underground was the explosion, it was not until November the following year that the last of the bodies were found.

Entering Platt Bridge the road becomes Platt Street, and soon after we turn right at the traffic island along the A58 or Liverpool Road. Another mile along here and there is a gap before entering Hindley, a region where a dismantled railway forms an artificial boundary which progress has yet to cross. Perhaps this is because of a second, even older boundary and one which the salters would have had to cross.

This is the confluence of two water courses, the Boredane Brook and Dog Pool Brook. More importantly it is where the salt route crossed into Hindley, for history records this as Salters Gate. Saxon or Old English *geat* does not have the same meaning as the modern 'gate'. Today, the word refers to the movable barrier across a gap, while the Saxon *geat* describes the path leading through that gap.

Having passed through the *geat* and into Hindley, there can have been only one destination. Indeed, by following Liverpool Road into Hindley it leads, having

negotiated one last traffic island, straight to Market Street. Since the early days as a Saxon settlement, the town has undergone many phases, most notably its heyday as one of Lancashire's cotton towns from the seventeenth until the middle of the twentieth century. It was also known for nail making from the seventeenth century, while the first coal mine is mentioned in a document of 1528.

The amount of salt brought here is not documented. This does not suggest the amount was trivial; indeed, over the centuries the cumulative total was probably substantial. In the years to come as archaeological methods improve, perhaps more details of this route will be uncovered and those gaps in the route filled in.

15

BUXTON TO SHEFFIELD

This salt route is a little different. In Chapter 6 we traced a network of routes which fed the land east of the River Trent; it did not start at a salt town or mine. Here we shall again start at a point on the route, for we know that Buxton was an important place as it stood where several well trodden tracks cross.

That Buxton would have been a distribution point is unquestioned; it has always been an important market town. We can also be certain that the turnpike road between Buxton and Sheffield, established in 1758, took an identical route already in existence as a salt route across the backbone of England. Indeed, the Act of Parliament clearly states the object of the exercise was to 'repair and widen' an existing high road, tolls raising the money for the upkeep of the road and making it self-sufficient.

To the Romans it was *Aquae Arnemetiae*; the spa town of the Victorian age was as important to the Empire almost two millennia earlier. However, this area of the Peak District is littered with examples of a much earlier occupation. Hardly a summit lacks a tumulus, low or stone circle, many of which are at least twice the age of the Roman remains; thus making these at least contemporary with, and possibly earlier than, Stonehenge.

One of these Roman roads still forms much of the route running from northwest to southeast straight through Buxton, today travelled by thousands of motorists every day as the A515. However, there is another road, between Buxton and Sheffield, which was also a Roman road and known as Batham Gate. The salt route certainly pre-dates the arrival of the Romans and thus their road to Sheffield and, while it would have been used by the salters during and after the Roman occupation, it was never maintained and soon fell into disrepair. Today, this path is so fragmented it is impossible to follow, hence we shall take the earlier route which became the turnpike road in the eighteenth century.

The salt doubtless came in to Buxton from Cheshire via Macclesfield. This would have taken the road known as The Street coming over Goyt Bridge, not the Macclesfield

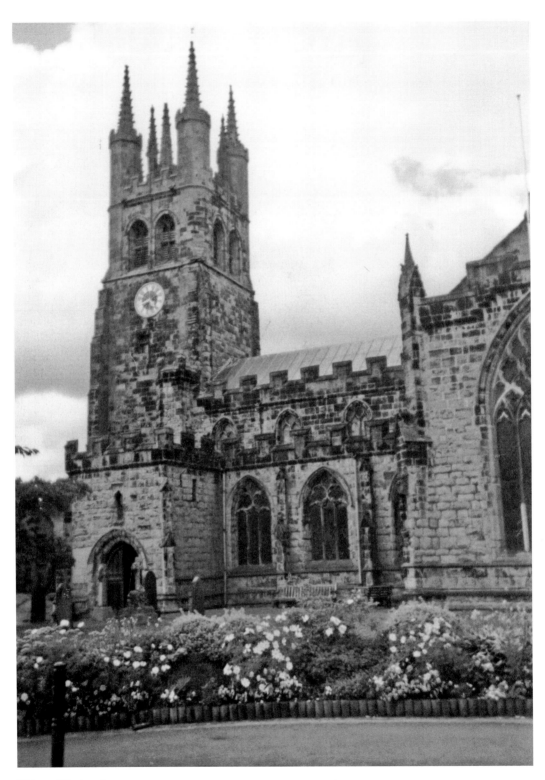

Tideswell's church.

The Derwent, Grindleford.

Road designated the A53. It is obvious where the salt was probably distributed from, for the road is still known as Market Street and this is where we shall begin, on the corner with High Street.

We then head north towards the railway station, turning right at the traffic island and following the A53 of Station Street, Bridge Street, under the railway viaduct of Spring Gardens, to the traffic island, where we join the A6. Turn left along Fairfield Road and up the hill for 600 yards and then, as we leave the town, turn right along Waterswallows Road. This road winds past the golf course and the quarry where quartz and amethyst has been extracted but is now registered as a Site of Special Scientific Interest, as it is home to a number of rare species of plants and animals.

In a little over two miles the road forks at Buxton Bridge; take the right hand road and cross the railway lines which served the now disused quarry, and up the incline towards Bole Hill. On the left, on the slightly higher summit, is a tumulus or burial mound. Standing on the top of the highest point around here, we are 1,322 feet above sea level, what was once clearly a visible man-made mound has weathered and no

The boundary road, Ringinglow.

evidence remains, making it impossible to date. Yet half a mile further along and one hundred feet below Bole Hill is Wind Low Barrow opposite Hayward Farm. Excavated in the middle of the nineteenth century, the skeletal remains of three adults, two children, unidentifiable burnt bones, and various grave goods were uncovered. This was a grave of some status, as indicated by the shale bracelet, and a necklace of jet and ivory. The remains of the base of a medieval stone cross sits on top of the barrow, which misled historians for many years.

Continue on to the crossroads, where we head straight across and follow the road as it winds around and down the slope of Wormhill Hill to the Monk Brook, and up the other side and into Tideswell. The parish church is dedicated to St John the Baptist, and is always referred to as the 'Cathedral of the Peak'. During the week of the summer solstice there is a celebration known as the Wakes, featuring a succession of events which have varying degrees of historical relevance. One piece of action by the local mummers (actors) explains why the inhabitants are referred to as Sawyeds. It seems that many years ago a farmer noticed one of his cows with its head stuck in a gate. His

solution was to saw the poor animal's head off! We also find a reference to the salt route here, with a thirteenth century record of Saltersford just as we enter Tideswell.

Our path takes us in to the village via Summer Cross, left on Sherwood Road, a quick right on to Parke Road, and directly across and to Commercial Road along the B6049 which then becomes Whitecross Road. It is almost two miles before we turn off towards Great Hucklow, a further half a mile away. This former lead mining village has much earlier origins, for the defensive earthworks of Burr Tor Iron Age fort are still visible to the north. This is also where the local gliding club is based and the turning point for the annual fell race, where competitors climb one thousand feet and back down over a race of six exhausting miles. For those who require a rest just thinking about this, the seventeenth century Queen Anne Inn offers good views to go with the food and drink.

Continue on east and, shortly after passing through Bretton, we come to a very straight road which climbs to 1,400 feet. There is no access to vehicles for the first part of this climb, they are forced to head south and loop around to skirt the famous plague village of Eyam which lies below Eyam Edge. While there is no doubt that this was constructed as part of the turnpike road, there are numerous suggestions as to the origin of the name first recorded in 1692. As far as surviving records show there was never a man associated with this region by the name of Sir William Hill, therefore it must be understood as 'the hill of Sir William'. However, there are several candidates, including the Lord of the Manor of Eyam and Sir William Cavendish of Stoke Hall. There is also the Sir William Hotel, but this was known as the Cavendish Hotel until the nineteenth century, while Sir William Bagshawe who is portrayed on the sign was not even born until 1771.

To the north is Eyam Moor, which is littered with historical features including 5 cairns, three stone circles, and an assortment of lumps and bumps. While the most famous circle has been given the name Wet Withens, the others carry the less imaginative names of Eyam Moor I and II. Sir William Hill Road peaks and then descends over 500 feet into Grindleford within a distance of half a mile.

At the bottom of this gorge is the River Derwent, reached by turning left on to Main Road and following the B6521 across the bridge and then following the road north through the delicious woodland that is Tawncliff Wood and along the gorge past Nether Padley and Upper Padley. Eventually this brings us to the junction with Hathersage Road, where we are going to turn right and continue generally northeast past the Fox House Inn and, half a mile further on, remains of an earthwork can still be made out under optimum conditions.

Just over a mile along the road bends sharply right; however, we will continue by taking the left turn along the Sheephill Road and Houndkirk Road towards Ringinglow another mile and a half along this road. At the junction there is the Norfolk Arms public house, popular with ramblers. Historically this is an important boundary, marked by the Limb Brook and Porter Brook, but also is the effective continuation of the Roman road which was known as Batham Gate and discussed earlier in this chapter. Today, this marks the edge of the Peak District National Park; for centuries it was the traditional border between Derbyshire and Yorkshire, while earlier still it stood at the point where the ancient Saxon kingdoms of Mercia and Northumbria met.

Heading east along Ringinglow Road for approximately three-quarters of a mile, we enter the outskirts of Sheffield and reach the junction with Eccleshall Road or A625, where we turn left. Four hundred yards along here we turn off to the right along Psalter Lane, a name which has existed for centuries – although in 1485 it is recorded as Salterlane. This is clear evidence that the salt route came through here and we can follow it as it points to the historic centre of the city of Sheffield.

This has been 26 miles where we have travelled from the spa town of Buxton, also famous for its Opera House, through to one of England's biggest cities and via some of the bleakest and unspoilt regions our islands have to offer. It was most rewarding to think much of the unspoilt region would have been just as the salters had seen it for hundreds, maybe even thousands of years.

CHAPTER 16

FAILSWORTH TO KNARESBOROUGH

Our final Cheshire salt route from takes us further north than any other, albeit only marginally further north than Hindley. This is one of the longest unbroken salt routes traceable today, a journey north which turns east and heads into Yorkshire on a journey of 75 miles.

We begin three miles from the centre of Manchester. To the northeast is the former independent settlement of Failsworth, now a district of the city which has obliterated much of the evidence in the landscape. Records suggest this route from Cheshire came through the 'broad ford' over the River Medlock at Bradford; however, to start at that point would make the journey complex and difficult to follow. Hence we find ourselves on Poplar Street as it crosses the Rochdale Canal between locks 67 and 68.

Heading north we turn right on to the A62 Oldham Road and, within a few yards, left on to the A663, aptly named Broadway. This is clearly a modern trunk road designed to take traffic away from the large conurbation as quickly and safely as possible. Yet ironically it follows a line very close to that taken by the salters, who would have been passing through open country here. Between the ancient and the modern routes developers and planners ignored the trackway and effectively buried it until Broadway was laid out.

Three miles along Broadway, crossing the M60 and the Rochdale Canal once more on the way, we come to Chadderton, a settlement with a long history and one which features in the distribution of salt. Chadderton is not found in Domesday, records begin 150 years later; however, archaeological evidence proves there had been a settlement here for over a thousand years prior to this.

We know the Saxons were here, for the tumulus at Chadderton Fold dates from between the sixth and eighth centuries AD. Roman evidence is found in the form of several Roman roads and countless artefacts. Earlier still are the relics found from the Iron Age, at the point near Chadderton Fold where travellers forded the River

Bacup town sign.

Irk. Doubtless this was also where the salters crossed the river and we can follow this track by turning left on to the A669 Middleton Road and, in 600 yards, right on to Chadderton Park Road. At the junction turn right and in 300 yards left along Mill Brow and cross the river near where the mill once stood. Continue and the road bears to the right and becomes Streetbridge Road, itself a Roman road and together two strong clues of this being the original route.

Continue around to follow this under the motorway, later to become Middleton Road, and a mile from the motorway turn left on to the A671 Rochdale Road at Royton. There is a record of a place name along the road between Middleton and Rochdale, where one Canon Raines refers to Salter Edge, but fails to give further details and the name cannot be traced on any surviving maps. Continue along the road towards Rochdale and pass through Hanging Chadder, where salt is recorded as being traded with one Richard de Hanging Chadder, an early landowner. Legends of this place being the site of gruesome gallows are unfounded; the *hangra* is a Saxon term simply describing higher or overhanging land. This Open cast mining and the production of strong cotton cloth, know as fustian, provided employment for most of the local population.

Another mile along this road and we pass under the M62 to come to an ancient boundary, which is well documented. Here are two early place names, Balderstone and

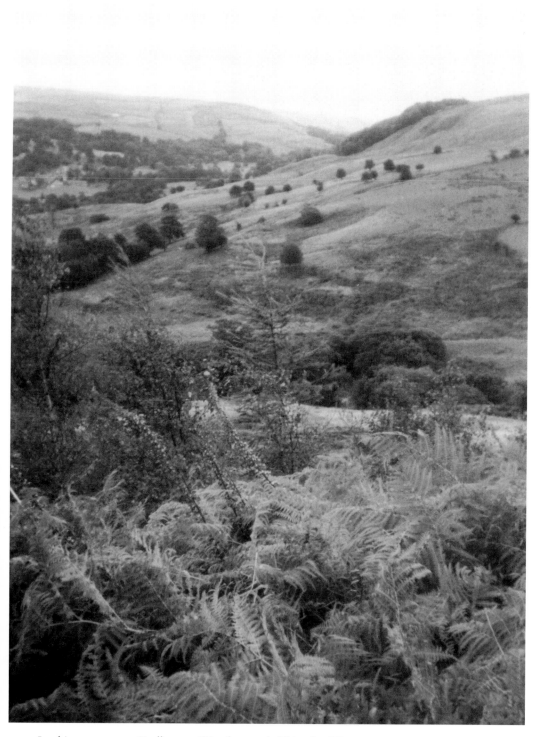

Looking out across Dodbottom Wood towards Thieveley Pike.

Salterford Lane, Mereclough.

Buersil, where maps from the Middle Ages and earlier show the defining boundary line following a line which can only have been some (now lost) water course. On these maps the boundary is named as Saltergate, the *geat* being a Saxon term for a through way.

Knowing we are on the right road we continue on the A671, along what is now Oldham Road, until shortly after crossing the railway to Rochdale station. Here the A671 turns right along Wood Street, then left along Molesworth Street, and John Street. Just where the road splits to form a dual carriageway is where we cross the River Rock at the point where the salters would have forded the river. Today the river would probably be missed, except by those who know its course and those who are looking for it.

Up to and across the island with its church, itself probably a signpost visible to salters heading towards Rochdale from the south. Here the route branches off to the east to bring supplies to Calderbrook and Walsden, following the line of the River Calder. However, we shall continue along the other route, along Whitworth Road, even though there are no signs of this being a salt route for some time. This is not what we would expect for, while there is evidence in the conurbations to the south, this is wilder country still with remnants of the Forest of Rossendale. Indeed, we pass through Healey and Whitworth, still along the same A-road, until three miles after leaving Rochdale we near the town of Bacup.

Tomb of the family of the Packmaster, St John's church, Worsthorne.

We have been following an ancient trail, one which is governed by the landscape and has been followed by the River Spodden. In the middle of the eighteenth century this road, realised as being an important road, was turnpiked to pay for its own upkeep. As we enter Britannia, south of Bacup, the road to the right is Tong Lane; as we leave the A671 temporarily we should reflect on this being marked on maps as Trough Gate, while older versions name this as Saltergate and a document of about 1200 speaks of Saltergat. Follow Tong Lane to Pennine Road; turn right and sharp left to continue along Tong Lane and into Bacup where we rejoin the A671. Turn left here and then right at the traffic island signposted towards Burnley.

Follow the road north and we come to a left turn in the road. Straight ahead a footpath takes us over Deerplay Moor and Thieveley Pike, a hike to a beacon 1,474 feet above sea level, descending steeply across the railway and reaching Holme Chapel on the A646. We then turn left here and follow the Burnley Road, until we come to Southward Bottom and Red Lees Road on the right. Meanwhile, the A671 can be followed around for four miles until we reach the A616 and turn right, heading south away from Burnley for two miles, thus coming to the same point as we did on foot at Southward Bottom.

Follow Red Lees Road to Mereclough, where The Long Causeway runs up to here from the southeast. This seemingly ancient route is actually a religious relic, a line of crosses and stone markers which probably mark some path of pilgrimage, although the

Offering a rest at Thornton-in-Craven.

real reason for its existence is a mystery. Half a mile north of Mereclough, leave the Red Lees Road after Newfield Farm and turn right along Salterford Lane, a clear indication of this being the salt route.

Three hundred yards along here is the ford itself, today marked by the place name of Saltersford Bridge where the salters crossed the River Brun.

As we continue further north, when the road changes to Ormerod Lane, there are obvious signs that this is an ancient route. On either side we see tumuli, stone circles, earthworks, crosses, and the remains of early settlements. Slipper Hill to the northeast of Worsthorne, the next village on this road, has a stone circle and ring stones with a few hundred yards of one another. Indeed, archaeological remains show continuous habitation from the Late Stone Age, including a six inch flint dagger. The church of St John's in the village contains the grave of a packmaster, a man whose job was to lead the train of packhorses across the ancient trails across England.

Leave Worsthorpe along the Extwistle Road, following its twisting path as it becomes Todmorden Road, until it reaches the first signs of Brierfield at the crossroads where the Burnley Road and the Halifax Road meet. Here, too, is the Roggerham Gate Inn on the Haggate Road, also where Noggarth Cross is traditionally held to be where a local witch remains trapped. Continue along Halifax Road through Lane Bottom and take the first road on the left, Robin House Lane. This takes us across the Catlow Brook

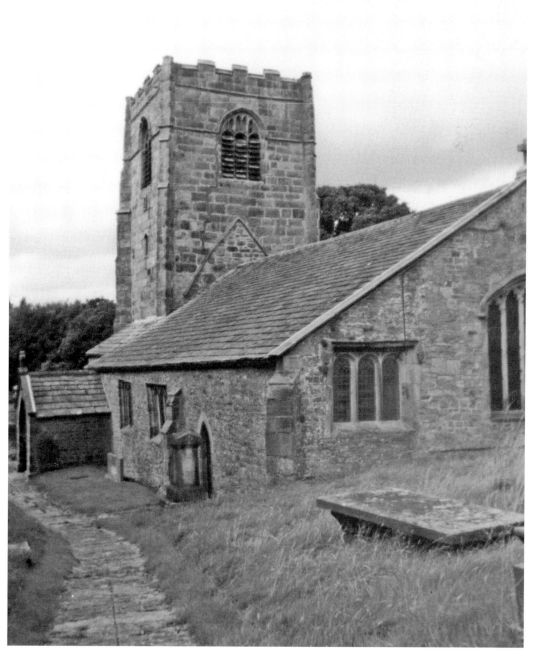

The church of St Mary the Virgin, Thornton-in-Craven.

The restored Holy Well, at the church in Thornston-in-Craven.

then along Southfield Lane, where we pass Castercliff, an Iron Age fort which was never completed and shows no signs of being occupied. At Birchenlee turn right on to Lenches Road, where it is signposted to Colne.

Just before the junction we cross the Colne Water, today via a bridge, but the salters would have forded this river. Then turn left on to Mill Green, right along Waterside Road, and then follow it as it becomes Colne Lane to the junction with the A56 Market Street. Turn right and follow the road through Colne and along the two miles to Foulridge through the two halves of the reservoir. Here the modern road heads straight for Earby; however, we shall follow the original route along the B6251 Whitemoor Lane and then High Lane to turn left, just after the Fanny Grey Inn along Salterforth Lane to the village of that name.

Clearly, Salterforth is so named because of its location on the old salt route, although most of the salters would not have seen the Leeds and Liverpool Canal as it was not started until 1770. This was not the water course which was forded, but an insignificant rivulet known as the Earby Beck which is also crossed again shortly afterwards. Follow Chapel Hill and Earby Road into Earby itself, where it predictably becomes the Salterforth Road once more, then turn on left onto the A56 Colne Road and head north to Thornton-in-Craven a mile and a half away.

The Shay, Harrogate.

As we enter the village the road on the left is a remnant of an old Roman road from Ribchester. Back here is a well which has been used since Saxon times; it was covered over by an odd octagonal construction in 1764 by the local vicar. Continue along the A56 and we pass Burwen Castle, a Roman fort which was served by the Roman road. This is actually two forts, one within the other. The earlier inner square fort dates to approximately AD 75; the later rectangular construction surrounded this and is from about AD 210.

At the junction take the A59 east and take advantage of the loop around Skipton, for there are no surviving clues that this route entered the town, although it seems impossible to think it did not. The route heads straight for Bolton Bridge, the place where the River Wharfe is crossed and would have been forded by the salters. This also marks the point where we leave the Yorkshire Dales National Park.

Continue on along the A59, the road looping around to arrive at Blubberhouses some seven miles from the River Wharfe crossing. Here our road crosses the River Washburn, again one which would have been forded by the salters, but which today is simply the means to fill the Thruscross, Fewston and Swinsty Reservoirs. Yet this was an important point on the road for this was where the route split, where what is now Shepherd Hill heading south was once labelled Snowden Bank and also Psalter Gate, and heading to Botley to pick up the other arm of this salt route which first split back at Colne.

Continue on along the A59 Skipton Road and we are soon on a very straight length which follows the line of an old Roman road. As this road leaves the line of the Roman road it follows a gentle incline to come towards the hamlet of Rowden and, 500 hundred yards after the crossroads, the next marker point in Saltergate Hill. Amazingly, this place name is listed no less than ten times during the seventeenth century, with as many different spellings! However, all carry the same message, that this was 'the hill on the salt route'.

From here we follow the A59 along into Harrogate, coming to the island in the district known as High Harrogate. This spa town, popular since the sixteenth century, contains many fine buildings. Of the two, the less publicised one is The Stray, an area of parkland in the centre of the town and visible to the right when we reach the traffic island. Over 200 acres were set aside by an Act of Parliament in 1778, should any part be used for building the same area must be allocated elsewhere to compensate. The Victorians organised an annual horse race meeting around a circuit here, created to preserve the quality of water from the natural springs which bubbled to the surface here. The second high point, in the author's opinion, is *Bettys and Taylors*, a tea and coffee merchant which has its own café here and one which retains much of its original charm.

Back at the traffic island turn right towards our final port of call Knaresborough. The salt would have made one last river crossing here, over the course of the River Nidd. The town has a long history, with many figures who have contributed in a number of ways coming from here. In 1129, Hugh de Morville was constable of Knaresborough, although he was in Canterbury in December 1170, when he was one of the four knights who slew Thomas a Becket in Canterbury Cathedral. It has also been shown that Maundy Money was first distributed in Knaresborough, by King John in April 1210, five years before he was forced to sign the *Magna Carta*.

However, the most famous former inhabitant of Knaresborough was a woman, Ursula Southeil (1488-1561), who is better remembered as Mother Shipton. As with Nostrodamus, she is credited with the gift of prophecy, foretelling a number of events including the Great Fire of London, a fact which is discussed in the diaries of Samuel Pepys. She enjoyed a rebirth in 1980, when it was pointed out that she foretold the end of the world in 1981. However, none of the so-called 'prophecies' appeared in print until over eighty years after her death. Mother Shipton was said to have been a hideously ugly hag, and is often said to be the basis for the pantomime dame. She lived in a cave downstream from the ford into Knaresborough and may well have witnessed the salters concluding their long journey as they crossed the River Nidd.

17

PINCHES OF SALT

Sodium Chloride, NaCl, occurs as rock salt or halite and is used today for much more than simply cooking. At the beginning of the twenty-first century, worldwide salt production was in excess of 210 million metric tonnes and hardly an industry on the planet does not make some use of this simple compound.

But where does it come from? The salt that is being extracted is the result of a dried up sea of some 220 million years ago; even when it is pumped up as saturated brine it is down to rainwater seeping down to dissolve the rock salt or, in some cases, where fresh water has been pumped into the band of salt to deliberately produce brine. The salty sea derives its salt from the land; however, there must have been a beginning to this cycle and the question remains – where did the salt come from? The answer is probably that it came from the land and was dissolved over aeons as the land was continually washed by the rains and rivers. However, there are those who maintain that the world's oceans came to our planet courtesy of the dirty snowballs called comets and, if this is the case, perhaps the salt came with it.

In ancient Egypt, the preservation qualities of salt were realised. Bodies buried in the dry sand of the Sahara, with its high salt content, were soon robbed of their moisture and thus preserved. An example of the effectiveness of this simple technique is on view in the British Museum. Affectionately known as Ginger, after the tufts of ginger hair still attached to his head, the 5,000 year-old body of a man was discovered in the sands of Egypt and was even better preserved than the mummification processes later adopted for their pharaohs. Indeed, it was these early burials which later developed into the mummification with which the ancient Egyptians are so well known. Some reports state how the bodies of the dead were immersed in brine for ten weeks before the embalmer got to work while, when she heard of the death of Mark Antony, Cleopatra ordered his body pickled in brine.

Salt was also used in the preparation of food left inside the great pyramids. The journey to the afterlife was a lengthy one with many tasks and trials to be overcome on

the way. Clearly even the mighty pharaohs needed sustenance on the journey, thus it was that a selection of foods were left within the tombs. Clearly the food would have gone bad equally as quickly as the body and so it was heavily salted and wrapped, much the same as the mummy it was meant to feed.

The value of salt in ancient times is seen in every major civilization that grew up around the Mediterranean. First there were the Phoenicians, a people from modern-day Lebanon where there was little arable land and therefore they were forced to trade. What Lebanon did have was trees; the wood was used to build ships and the Phoenician navigators travelled all around the Mediterranean, are known to have visited Britain, the coastline around Africa and at least as far as India.

By creating channels they allowed the sea to flood the marshes, then dammed those areas and allowed the warm Mediterranean sun to evaporate the water, leaving behind tons of natural salt. This is a simple process and one which is almost labour free, when compared with the working conditions in the salt works of Cheshire and Droitwich.

Not only did the salt itself bring great wealth, but their skills as mariners saw them net great quantities of Mediterranean tuna on a scale never before seen. Tuna are fish of the open ocean and the problem had always been getting the fish to port before they started to rot. Salt enabled the Phoenicians to preserve their catch and cash in on a new market. Over one thousand years they rose in power and influence, establishing numerous cities including the most famous of Carthage in modern Tunisia.

One of the most valuable items they traded were the spices and, in this era at least, the most precious spice was pepper. The two items are still linked on tables all around the world and yet the irony is that the devaluation of salt was directly linked to the influx of pepper.

From around 600 BC the Phoenician influence was in decline, hastened by something very much in the news in the twenty-first century – climate change. A few years of very extreme weather for the region meant that storms destroyed almost half of the salt pans; the rest were ruined by the incessant rain, making evaporation impossible. As a result, their economy was dealt a blow from which, at least collectively, they never recovered. The individual cities fell; eventually, even the might of Carthage was no more.

Archaeologists have shown salt to have been extracted at Droitwich since at least 200 BC. However, there are signs of human habitation in the area from 8000 BC. This was around the time when our islands were comparatively recently separated from Continental Europe and before the nation had settled to an agrarian lifestyle. It is tempting to suggest that they were using the brine which bubbled to the surface, for they would certainly have needed extra salt in their diet. However, their method of extraction left no record to prove this.

Even with the technological advances of the twenty-first century, salt could still have a major influence on our future and possibly even more so than in the past. The Gulf Stream brings the warmer climate of the equatorial regions along the east coast of North America and to the eastern coastline of Europe as far north as Norway. Hitting the cold waters of the Arctic one would expect warmer water to rise above it, but the increased salinity of the warmer water makes it denser and it sinks. Eventually, through

a complex system, the waters of the Gulf Stream return to the equatorial regions and begin the cycle once more.

Global warming melts the polar ice, introducing more fresh water into the system leading to the deflection or even cessation of the Gulf Stream. Thus the system of heat exchange around the planet is radically altered and, odd as it sounds, global warming could produce a much colder Britain as much as a warmer one.

And all because of salt.

Salt has become very much a part of our culture; not only for the traditional British fish and chips, but all over the world and in the most unusual ways. In the east, an honoured guest would have been welcomed by the blood of an animal sacrificed outside the entrance. In the event of a surprise visit, salt would have been scattered at the entrance, thus showing that salt was considered almost the equal of blood.

Greek philosopher Aristotle, writing in the fourth century BC, encourages the eating of a measure of salt as an offer of and sealing of a friendship. Thereafter to renege on that friendship would have been tantamount to treason. Russian traditionalists have no opportunity to carry their bride over the threshold, for they will already have a lighted candle in one hand and a measure of salt in the other. Perhaps this was the same measure of salt which had been handed to the bride and groom as a traditional wedding gift. In Denmark, visitors to those on their death bed will throw salt on the open fire in order to ward off the devil.

Salt is also ingrained into our language. We have already noted how the Latin for salt has provided us with the word salary. Yet the Roman troops were paid in salt, the common currency throughout the Empire, and the word 'soldier' is derived from this. Latin *sal dare* means quite literally 'to give salt' and not only gave English 'solider', but also French *soldat*. The word salinate, meaning 'to change completely, in essence', is derived from the Latin *salinator*, the servant whose duty required him to pound lumps, clean and store the salt for the household. Roman *salarium* was the payment made to salt workers who extracted the salt, while a *saller* was the ancient salt box which kept the salt clean and dry and is seen today on every table as the salt 'cellar'.

However, in some parts of Africa salt coinage was in use up to at least the nineteenth century. In very hot countries salt was even more important, vital to the health of the people and predictably taxed unfairly. Some may recall how Mahatma Gandhi took the long trek through India to the sea. Here he boiled the sea water to evaporate the water, thus highlighting how unfair it was to tax a necessity.

To 'take with a grain (or pinch) of salt' warns we should be sceptical of the validity of whatever is being spoken of – in Latin, this is *cum grano salis* and the English phrase first recorded in 1647. Another commonly heard phrase is describing someone as 'worth one's while'; however, this seems to be a more recent addition to the language and is not known in English before the nineteenth century.

Less well known, as they have largely fallen out of use, are 'to sit above the salt' and 'to sit below the salt'. Clearly there is a demarcation line here, but this is not a line of salt. In the sixteenth century, salt was subjected to high taxation and was ridiculously expensive in comparison to today. Hence it was associated with the tables of the rich and, as it was the norm for the rich to sit at the higher tables and the rest lower down,

to be seated 'above the salt' recognised you were the equal of the host. Note that the salt would have been held in as ornate and expensive a container as the host could reasonably afford, for it was not sufficient to know where the salt was; it had to be clearly seen.

Some indication of the degree of taxation can be seen by the last rise imposed. It happened in the reign of William and Mary; the year was 1805 and, while Admiral Lord Nelson was planning the downfall of the combined French and Spanish fleets at Trafalgar, the Customs Service was raising the tax on salt to £30 per ton. At the time, the weekly wage of a dockworker, farm labourer and sailor was approximately seven shillings (35p), which would give the same spending power as £14 a week in the early twenty-first century. If you consider that to be bad, spare a thought for those in Europe where the French had to be content with the equivalent of just 20p, and the German economy meant their dockers took home just 13p per week. In 1825, the despised Salt Tax was abolished by the British government, the same year as the vast salt deposits were discovered at Stoke Prior.

These were by no means the earliest known examples of salt tax. The first salt tax in England was imposed by William III (1650-1702); the Russians were taxed by Peter the Great (1682-1725); Hungary and Germany were taxed from the thirteenth century, France from the twelfth; the Syrians paid a salt tax to Alexander the Great (336-323 BC); the Romans extracted a salt tax from the Jews; Egyptian kings levied a salt tax on the priests of Hammomen; while the first datable written record of a salt tax was by Ancus Martius, author of *Salinarum Vectigal* in 640 BC.

As the Saxon feudal system of government took shape, so the officials were quick to impose fines, tolls and taxes in any way they could. From the Cheshire wyches salt already provided a hefty income for the Earl of Chester and the Crown. Fines and tolls for those from the local hundred were at least half and as little as a quarter of those paid by visitors. For example, the toll for a cart drawn by two oxen was tuppence, for four oxen fourpence, one packhorse a ha'penny, eight manloads a penny, and these were the local rates.

Overloading a cart or horse, thus avoiding tolls, was not wise either, for if the cart axle snapped or the horse's back broke within one league of the wyches meant a fine of two shillings, assuming they were caught – a league is a distance which changes depending upon the era and location, but could be seen to be the distance travelled in a single hour. Outside of that league the officer had no jurisdiction. As the salt was packed tightly into the containers, unscrupulous traders were known to split the containers to form two loosely packed loads from a single tightly packed one. While this meant the trader would have to pay twice as much in tolls, he would more than recoup that when he sold the load on. However, this did not look good on the supplier and, should he be found to have split the load, would realise a massive fine of forty shillings.

Aside from the obvious culinary uses, the chemical industry require salt to produce hydrochloric acid, caustic soda and sodium metal. Drug companies are only a part of the numerous medical uses. Salt is used in the manufacture of paint, bricks, tiles, glazed pottery, leather tanning, shampoo, glass, yoghurt pots, plastics, slug repellent, for piping, as a water softener, on icy roads, in soap manufacture, in dyes, in agriculture, and in

the production of metals such as brass, bronze, aluminium, gold, silver, and zinc. Food stuffs containing salt include bacon, fish, bread, jams, ketchup, ice cream, butter, cheese, pickles, and even confectionery.

John Corbett, the Salt King, had an array of managers working for him who looked after the daily running of the Stoke Works at Droitwich. One of these men had settled at Elms Farm, just a few hundred yards walk to work each day along Weston Hall lane. Mr Grafton and his young bride regularly entertained her brother, who arrived by train and would have walked past the salt works to reach The Elms. A common enough occurrence, but one where the visitor was about to be better known than even Corbett, for Mrs Grafton's maiden name was Elgar and this was her brother Edward, later Sir Edward and Master of the Kings Music.

Those who worked on the shop floor had a hard life. Wages were poor, working conditions necessarily hot and hours were long. Whole families were engaged in producing salt, an image depicted on the statue entitled the Saltworkers. Such conditions, as seen with mining communities, where a great number of generations are tied to a particular industry through a lack of any alternative way of earning a living and with no new blood from outside, see the family names become fixed in the area.

Anyone who has traced their family tree will be aware that the first born son and daughter would be named after the father and mother. Subsequent children would then take the names of uncles and aunts, cousins and grandparents. This lead to many individuals having the same name and the community took to giving nicknames. Such were not, as is often the case today, derogatory, but a reflection of the individuals skills or job and thus seen as almost a badge of office.

For example, over three generations there were no less than twenty men by the name of George Harris in Droitwich. Their surname, while recorded, was hardly ever used in favour of their nickname – even by their employers. Thus we find Harris as a surname becomes Smoker, Dukes, Fantail, Pigeon, Ballis, Stafford, Tant, and even one example of one William Harris who was known as Billy Old Hen. Note this is not their Christian name which is replaced here, but the surname – hence we should not be looking for Smoker Harris, but Georgie Smoker.

Meanwhile, other families attracted different alternatives. The Harrison family had individuals called Banes, Cloggy, Tottenham, Buffer, Bantam, Hobby, August, Wanna, Noggy and Gomfrey. The Bourne family, who had a long association with Droitwich, kept their surname but to each was added a suffix and became Bourne-Tow, Bourne-Molly and Bourne-Column. Other branches of this family took the same route as the Harris clan, and thus we find Blue, Bobbem, Gory, Tongy, Dandy, Panto, Boniker, Rabbit, Pie and Jinkum. The Nicklin family somehow managed to acquire the nickname of Nick, through Jimmer, Joey, Harry, Peckum and Weighum. The Cuckoos were all of the Pittaway line, the Colleys became known as Toodle, and the Duggans had their name changed to Diddle.

Family connections, although the main source of nicknames, could and would be ignored in favour of a more personal reference whenever the individual was deemed to merit such. Two examples stick out, although neither of these have any written explanation, but which suggest enough for us to have some idea of what was being

implied. For example, maybe the morals of a lady by the name of Joe Tom George's Lizzie's Rose are questionable, to say the least; while the reader should make up their own mind as to the reasons why one gentleman was known to one and all by the name of Three-Elbowed-Dick.

In Cheshire, where the production of salt was over a wider area and other industries provided opportunities to work outside salt production, the community was not reliant on a few families. However, regional dialect words did develop, even as they continue to do so today, despite the exposure to a more national or even multi-national English, thanks to the ease of travel and instant interaction.

Local terms are particularly evident in jobs and in the tools used by these individuals. Common salt pans were up to one hundred feet in length and worked by gangs of men known as wallers. These men had the job of turning the evaporating brine as it thickened and the salt crystallised out. Not a pleasant job at best, owing to the extreme heat and the dehydrating effect of working so closely with salt. However, evaporation was never even throughout the brine mixture, even in the smallest pans and here they were huge. In order to reach every part of the pan with their rake-like implements, the wallers were required to stand in half barrels placed IN the boiling brine!

Tool names varied from place to place and even from one works to another, hence a mundler, a mundling stick and a punner were all the same thing. In Victorian times, the tubs and storage vats used to drain excess brine remaining in the salt were made from elm. They came in sizes known as 40s, 60s or 80s and the salt was packed down by using the mundling stuck, whereupon it would be left to dry out and produce blocks or lumps of dry salt. Other tool names included rake, chipping paddle, lofting spike, happer, skimmer, mundling peg, salt tub, cotter patch, and bagging shovel.

Commercial salt extraction started near the modern Marbury estate near Northwich around 1670. The layers of rock salt, some eighty feet thick, were mined, leaving columns of rock salt supporting the ceiling. Unfortunately, these caverns regularly flooded and the pillars were dissolved, causing the land to collapse into the caverns below. Taken overland to Frodsham Bridge, the rock salt was then shipped along the River Mersey, where it was dissolved in sea water and refined. A rapid increase in business followed the work to make the River Weaver navigable from 1721. However, all this was based on a lucky discovery, for these salt mines were only discovered by accident when John Jackson was prospecting for coal in 1670.

Salt workers everywhere were known for dipping all manner of personal items in the brine to produce highly unusual decorations. Each dipping in the brine solution left a film on the item and, as successive dippings dried, a layer of crystals became encrusted on the item. All manner of objects were dipped including plenty of old shoes.

Northwich Victoria, the local football team who regularly come to the attention of the nation when they appear in the early rounds of the FA Cup, is nicknamed the Salt Boys.

When Queen Victoria came to visit during her long reign, the town wanted to add a local flavour to the decor in order to welcome the reigning monarch. During this era, decorative arches appeared in quantities not seen since the Roman era. Hence the town produced an entranceway, a construction made from local salt, with the bottom

supporting pillars cut from brown rock salt, topped by an archway of white salt blocks. It is not recorded how long they withstood the weathering of the British climate after the Queen and the local dignitaries had passed underneath.

BIBLIOGRAPHY

Droitwich and the Salt Industry by A. F. Nicklin

John Corbett, Pillar of Salt, 1817-1901 by Barbara Middlemass and Joe Hunt – Saltway Press (1985)

Transport of Salt: Droitwich and Salt Works by A. F. Nicklin

Droitwich Heritage Centre

Salt Museum Northwich

The Ancient Highways and Tracks of Worcestershire and the Middle Severn Basin Parts I, II and III by G. B. Grundy (1934-35)

Saltways by F. T. S. Houghton – Transcript of the Birmingham Archives Society (1930)

Saltways of the Droitwich District by Dr Whitley – Transcript of the Birmingham Archives Society (1926)

Saltways from the Cheshire Wiches by W. B. Crump – Transactions of the Lancashire and Cheshire Antiquarian Society (1934)

Salt in Cheshire by Albert F. Calvert